CASPAR DAVID FRIEDRICH

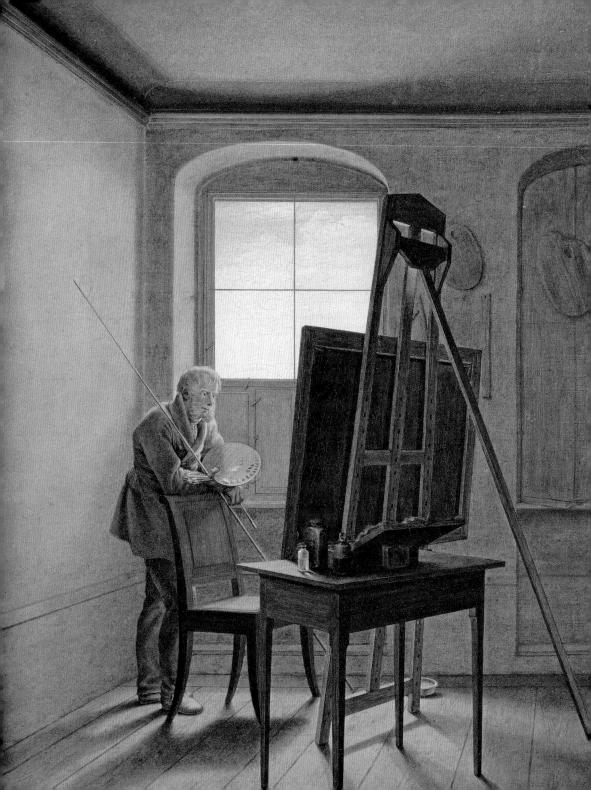

CASPAR DAVID FRIEDRICH

Michael Robinson

PRESTEL

Munich · London · New York

Front Cover: Village Landscape in Morning Light (The Lone Tree), 1822,
Alte Nationalgalerie, Staatliche Museen, Berlin (detail, see page 93)

Frontispiece: Georg Friedrich Kersting, Caspar David Friedrich in His Studio (II), 1812,
Alte Nationalgalerie, Staatliche Museen, Berlin
pages 08/09: Moonrise over the Sea, 1822 (detail, see page 89)
pages 38/39: The Large Enclosure, c. 1832 (detail, see page 105)

© Prestel Verlag, Munich · London · New York 2023
A member of Penguin Random House Verlagsgruppe GmbH
Neumarkter Strasse 28 · 81673 Munich

A CIP catalogue record for this book is available from the British Library.

Editorial direction, Prestel: Cornelia Hübler
Copyediting and proofreading: Russell Stockman
Production management: Andrea Cobré
Design: Florian Frohnholzer, Sofarobotnik
Typesetting: ew print & media service gmbh
Separations: Reproline mediateam
Printing and binding: Litotipografia Alcione, Lavis
Typeface: Cera Pro
Paper: 150 g/m² Profisilk

MIX
Paper | Supporting
responsible forestry
FSC
www.fsc.org
FSC® C147178

Penguin Random House Verlagsgruppe FSC® N001967

Printed in Italy

ISBN 978-3-7913-7993-7

www.prestel.com

CONTENTS

INTRODUCTION

The *Oxford Dictionary of Art* describes Caspar David Friedrich as 'the greatest German Romantic painter' in the landscape tradition. Yet it is important to note that the artist was largely forgotten for more than half a century and rediscovered only after Germany had become a nation-state. Much of Friedrich's work had been political and patriotic, produced during Napoleon's invasion and the country's subsequent reactionary reorganisation.

What exactly is meant by the Romantic era? From the mid seventeenth until the last quarter of the eighteenth century, Enlightenment thought and culture prevailed in most of Europe. It was the Age of Reason, noted for its intellectual debate and empiricism. Painting, at least in most of Europe, was Neoclassical in style and landscapes appeared only as incidental backdrops for mythological or historical motifs. A perfect example is *Napoleon Crossing the Alps*, painted in 1800 by Jacques-Louis David (1748–1825). In Holland, however, artists like Jacob van Ruisdael (1628–1682) had begun painting landscape for its own sake. Friedrich saw many such paintings at the Academy in Copenhagen and later in Dresden.

The reaction against the Enlightenment, particularly in landscape painting, was essentially an Anglo-German phenomenon. An early challenge to Enlightenment aesthetics in England was the treatise *A Philosophical Enquiry into the Origin of Our Ideas of the Sublime and Beautiful* (1757) by Edmund Burke (1729–1797); this was followed in Germany by the critique *Observations on the Feeling of the Beautiful and Sublime* (1764) by Immanuel Kant (1724–1804). Both philosophers questioned the aesthetics of Neoclassical painting. Burke makes the point that the 'beautiful' is ordered and pleasing, whereas the sublime is an aspect of nature that can compel and even destroy us. Kant expanded on Burke's argument by identifying three kinds of sublimity, the 'terrifying' sublime accompanied by dread and melancholy, the 'noble' sublime which is a quiet wonder, and a 'splendid' sublime which contains aspects of beauty. Kant's distinctions are notably reflected in the highly varied painting of Caspar David Friedrich.

Romanticism was characterised by individualism, the use of personal emotion as an aspect of aesthetic experience, a love of and sense of awe in nature and most often a spiritual awareness of man's comparative frailty. The main proponents of this aesthetic in landscape were J. M. W. Turner (1775–1851) and John Martin (1789–1854) in Britain and Caspar David Friedrich and his pupil Carl

Gustav Carus (1789–1869) in Germany. It is helpful to refer to Friedrich's paintings as 'moodscapes', for in many ways they are hard to categorise within the broad spectrum of a Romantic or sublime aesthetic. In his time these contemplative paintings were unfathomable to most viewers and understood by only a few aesthetes. There is often an ambiguity about his work with its elements of religiosity, symbolism and allegory. Perhaps its most lasting impression is its sadness.

 We know little about his private life beyond letters written by and to him. He was a very private person, deeply religious, sometimes described as affable and sensitive but essentially a loner living an ascetic life. He married when he was in his forties and had three children, spending most of his life in Dresden, with occasional sojourns in his hometown of Greifswald and on the island of Rügen. In the last decade of his life Friedrich was debilitated by ill health, his reputation had declined, and he died in 1840 in poverty. It was not until the twentieth century that his work was subjected to a reappraisal by artists and art historians, and we are now able to relate key paintings to successive periods in his life and make them more readily understood and appreciated.

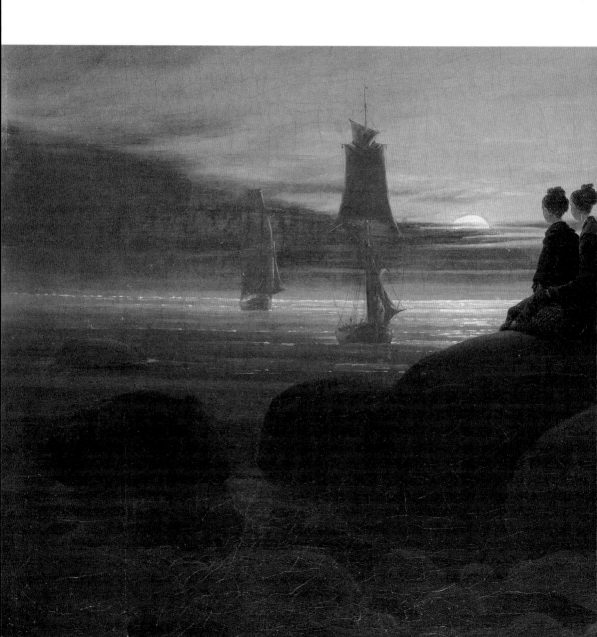

LIFE

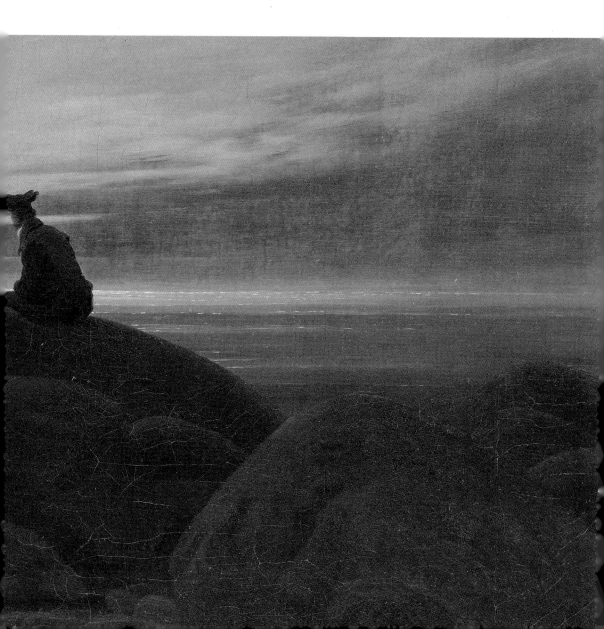

'The artist should not only paint what he sees before him, but also what he sees in himself.'

Caspar David Friedrich

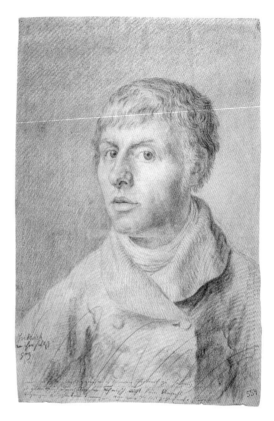

Self-Portrait, c. 1800

Caspar David Friedrich (1774–1840) was one of the giants of European Romantic art. The above quote clearly indicates what was important to him and his contemporaries. They not only demonstrated a new appreciation for nature, they sought to capture their subjective response to it in their prose, poetry and visual art. Friedrich's birth and death dates roughly correspond to the beginning and end of Romanticism in Germany: the year of his birth saw the publication of a shocking novel by Johann Wolfgang von Goethe (1749–1832), *The Sorrows of Young Werther*, one of the key works from the brief pre-Romantic 'Sturm und Drang' period, and by 1844 the movement was giving way to a new Realism.

Sturm und Drang (Storm and Stress) was a distinct departure from Enlightenment values and Neoclassicism, highly emotional, subjective and filled with turmoil. It took its name from the title of a play published in 1777 by one of the movement's representatives, Friedrich Klinger (1752–1831). In art the trend was exemplified in the nightmarish, violent and supernatural paintings of Henri Fuseli (1741–1825). In literature, along with Goethe, the younger Friedrich Schiller (1759–1805) was a major contributor. Among Friedrich's earliest works were illustrations for Schiller's play The Robbers (opposite). The plays and novels of the period tended to feature non-aristocratic protagonists driven to violent action by greed, a desire for revenge or unrequited love, and in their subjectivity, as opposed to the objectivity of Neoclassicism, they prefigured much of what would characterise the subsequent Romantic movement.

Friedrich was born on 5 September 1774 in Greifswald, a once prosperous port on the Baltic Sea that formed part of the Hanseatic League. He was the sixth of ten children born to the strict Lutherans Adolf Gottlieb and Sophie Friedrich. Adolf made his living as a candle-maker, although little is known about the family's economic situation. Greifswald, then part of Swedish Pomerania, was a large medieval town with its own university (founded 1456). Nearby were the ruins of Eldena Abbey, a thriving Cistercian monastery dissolved during the Reformation.

Scene from Schiller's *The Robbers* (Act 5 Scene 7), c. 1798

Friedrich became familiar with death at a very early age, for his mother died in 1781. Probably the most traumatic event in his life was watching his brother Johann drown after falling through the ice in 1787. These and other tragedies almost certainly influenced his later obsession with death.

In 1790 Friedrich started taking private drawing lessons under Johann Quistorp (1755–1835), the

drawing master at Greifswald University. He was mainly tasked with sketching plaster casts of antique sculpture. Friedrich would maintain a close relationship with Quistorp throughout his life, and together they undertook various drawing trips. Quistorp owned a large art collection that included work by Adam Elsheimer (1578–1610), noted for his nocturnal paintings on religious subjects. Features of his influential *Flight into Egypt* (1609) can be found in Friedrich's later paintings. Quistorp also introduced the younger man to the philosopher Thomas Thorild (1759–1808), a professor at the university and proponent of the Sturm und Drang movement who gave Friedrich instruction in aesthetics.

Another influence on Friedrich was the theologian, pastor and poet Ludwig Gotthard Kosegarten (1758–1818). A pantheist, Kosegarten taught that God and the universe were one and the same, and that God was revealed in nature. It was thanks to his writings that early on Friedrich focussed on such subjects as the Nordic landscape, moonlight and pagan burial sites like the dolmens found on the island of Rügen.

In 1794 Friedrich began his formal art education at the Copenhagen Academy (later Royal Danish Academy). For the first three years he copied drawings and drew from casts of classical sculptures. Only in his final year was he admitted into the life class. Oil painting was not taught at the Academy, but Friedrich had access to the Royal collection of Dutch art, which included many oil paintings of landscapes. There is little surviving evidence of his studies there, but it was under the tutelage of the history painter Nicolai Abildgaard (1743–1809) that he concentrated on figure studies and, more importantly, composition. His early drawings illustrating scenes from Schiller's play *The Robbers* (page 11) clearly document this influence.

Friedrich also profited from his study of paintings by the Academy's director Jens Juel (1745–1802). Though best known as a portraitist, Juel also painted *Landscape with the Northern Lights* (1790s), a 'sublime' picture that must have greatly impressed the young student. During his years at the Academy Friedrich explored the countryside around Copenhagen. One of his paintings from that time features the nearby monument *Emilie's Spring* (pages 40/41), a motif already painted by Juel in 1784. Before completing his studies, in 1798 Friedrich moved to Dresden to be 'close to the finest art treasures and surrounded by beautiful nature'. The move coincided with the arrival there of Friedrich Schlegel (1772–1829), a key literary figure in early (Jena) Romanticism who with his brother August Wilhelm established the *Athenaeum*, a journal that would become the unofficial organ of the movement.

Friedrich began to make a name for himself at the Dresden Academy under the tutelage of Johann Christian Klengel (1751–1824), whose pastoral landscapes were an inspiration. In March 1801, however, he suddenly decided to take an extended trip to Greifswald via Neubrandenburg and did not return until the summer of the following year. The reasons for the sudden departure are unclear, but Friedrich was predisposed to

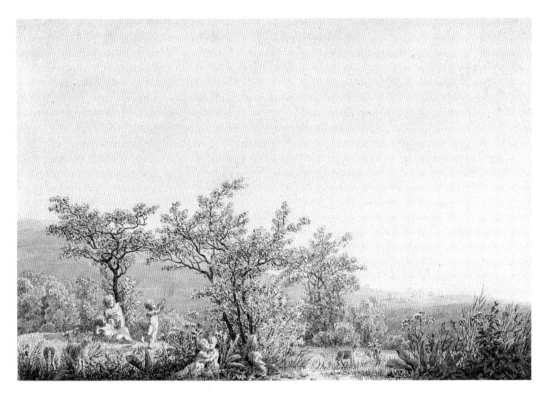

Spring, c. 1803

melancholy, and he may have been homesick. It was in Greifswald that he met the artist Philipp Otto Runge (1777–1810) from nearby Wolgast. Runge had recently returned from his formal art education, also at Copenhagen Academy, and introduced Friedrich to the notion of depicting landscapes in different seasons or at different times of day as metaphors for life's passages and spiritual aspirations. Friedrich then produced a number of such scenes in sepia in 1803 and would often return to this subject matter in his later work.

In August 1801 Friedrich set out on a walking tour of the island of Rügen, about 40 km from Greifswald, accompanied by his former drawing teacher Quistorp. For Friedrich this beautiful island, the largest in Germany, not only provided motifs for his paintings, but also served as a retreat where he could convalesce after subsequent bouts of illness. The following year Friedrich returned to Rügen for another stay and began working in sepia and gouache for the first time. There are a number of paintings among his early works, most notably *The Ruins at Eldena with a Funeral* (page 14/15), from 1802/1803, in which a cross is incorporated into the landscape.

On his return to Dresden Friedrich took up his career as a landscape artist in earnest, painting nearby locations like the Plauenscher Grund, a valley about six kilometres southwest of Dresden, and Loschwitz on the Elbe, a spot he returned to again in the summer of 1803. By 1805 Friedrich was

The Ruins at Eldena with a Funeral, c. 1802/1803

confident enough in his work to submit two sepia paintings to the annual art exhibition sponsored by the Friends of the Arts, a society established by Goethe, at Weimar, about one hundred and seventy kilometres west of Dresden. Weimar was an important centre for literature and the arts, mainly thanks to Goethe's presence. It was here that Friedrich first tasted success; the two works, one of them his *Pilgrimage at Sunrise* (pages 44/45), were awarded first prize.

With the arrival of Napoleon's troops in Prussia in 1806 Friedrich appears to have lapsed into a melancholic state, and in the spring headed for his hometown and on to Rügen, where he spent the summer. In the following year, having returned to Dresden, he began painting in oils. One of his earliest works in the new medium was *Summer* (page 18), a large pastoral landscape clearly influenced by Claude Lorrain (1600–1682), especially its inclusion of a young couple sheltering in a bower. Friedrich had explored the subject as part of a cycle of the seasons in a series of drawings in 1803. Also dating from 1807 is his *Dolmen in Snow* (pages 46/47), a particularly bleak picture of a pagan burial mound in winter.

His most disconcerting and controversial work from this time was *The Cross in the Mountains*, also known as the *Tetschener Altarpiece* (pages 48/49). The work had a mixed reception, the most vehement criticism coming from the art critic and Prussian diplomat Friedrich Wilhelm Basilius von Ramdohr (1757–1822), who objected to the use of landscape as an altarpiece. In the aftermath of the 'Ramdohr Affair' Friedrich lost much of his earlier support, including that of Goethe, and he once again sought sanctuary back in Greifswald. Despite Goethe's lack of enthusiasm, between 1808 and 1810 the ducal court at Weimar acquired five of the artist's paintings.

With renewed vigour, in 1810 Friedrich set off on a walking tour in the Riesengebirge, close to Saxony's border with Bohemia. He was accompanied by his fellow artist Georg Friedrich Kersting (1785–1847). The painting *Morning in the Riesengebirge* (pages 56/57) was conceived during this excursion. In order to cultivate new outlets for his work beyond Dresden and Weimar Friedrich exhibited two oil paintings at the Berlin Academy's exhibition in the late summer of 1810: *Monk by the Sea* (pages 50/51) and its companion piece *Abbey in the Oakwood* (pages 52/53). They were enthusiastically received, despite the fact that they were very different and difficult to reconcile as pendant paintings – a frequent feature of the artist's pairings. Despite this Friedrich was elected to the Berlin Academy, an honour that provided a significant boost to his reputation. In December 1810 his friend Runge died at the young age of thirty-three, and it was possibly in homage to him that Friedrich resolved to continue painting seasonal and diurnal cycles.

In the summer of 1811 Friedrich embarked on a walking tour of the Harz Mountains accompanied by Gottlob Christian Kühn (1780–1828), the sculptor who had carved the frame for the *Tetschener Altarpiece*. The region's lush evergreen forests, mountains and rugged landscape provided him with extensive motifs for future paintings.

Dolmen by the Sea, c. 1806/1807

Friedrich never painted outdoors; his landscapes were composites of sketches made in nature but painted in his studio. The fir trees seen in *Winter Landscape with Church*, from 1811 (pages 58/59) were very likely patterned after sketches made in the Harz region. *The Chasseur in the Woods*, from 1813 (pages 62/63) is also probably a reflection of that landscape. In the late autumn of 1811 Friedrich submitted nine paintings to the exhibition at Weimar, including *Winter Landscape with Church* and *Morning in the Riesengebirge* (pages 56/57). By this time interest in Friedrich's paintings was waning, and they were being harshly criticised. It

is unclear what Goethe found objectionable, but it may well have been the inclusion of a cross in these paintings, something he had reviled in 1790 in his *Venetian Epigrams*.

By 1812 Friedrich's work was becoming more political and patriotic in subject matter, a reflection of Prussian sentiment following the invasion and defeat of its army by Napoleon in 1806/7 and subsequent punitive reparations imposed on Prussia under the terms of the Treaty of Tilsit. In May 1812 Napoleon was in Dresden himself, using it as his main base while preparing for a decisive battle with the Prussians in August. One of the earliest of

Summer, 1807

Friedrich's patriotic paintings was *Tombs of Those Fallen in the War of Independence* (pages 60/61), a clear condemnation of Napoleon.

After the city was liberated from the French the painting was shown in Dresden at an exhibition of patriotic art in 1814. Before the liberation Friedrich embarked on a walking tour of the Elbsandsteingebirge (Elbe Sandstone Mountains) on the border between Saxony and Bohemia, staying in the village of Krippen. Another patriotic painting shown at the Dresden exhibition was *The Chasseur in the Woods* (pages 62/63), which pictures a lone French cavalry officer

about to penetrate a dense forest of fir trees on foot. Separated from his horse, he is likely to be ambushed by a vengeful Prussian or perish in a hostile German nature.

After Napoleon's final defeat and the restoration of all of Prussia's confiscated territories at the Congress of Vienna in 1815, the resultant German Confederation was heavily criticised by liberal thinkers of the time who wanted a fully unified German republic. At the Congress Swedish Pomerania had been ceded to Prussia. Although each of the thirty-nine states of the Confederation was technically independent, they were all

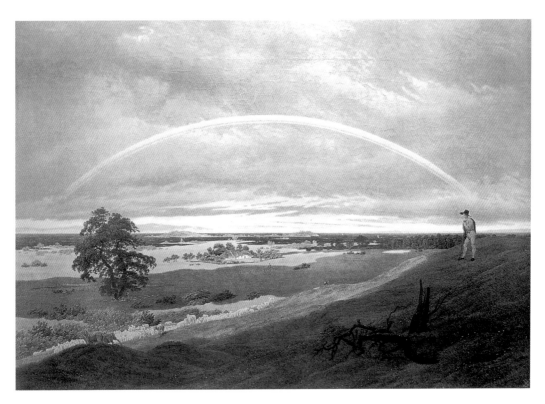

Landscape with Rainbow ('Shepherd's Lament'), 1809

subject to federal law. The two chief members of the Confederation were Prussia and Austria, each of which had a powerful monarch and refused to entertain the idea of a German republic. A number of new laws placed severe restrictions on the press, university teaching and student participation in protests. The liberal Friedrich saw his fellow citizens of the Confederation as 'slaves of princes'.

Distressed by the Confederation's conservatism, Friedrich once again took refuge in his Baltic homeland, Greifswald and the island of Rügen. There he began painting a series of more traditional landscapes and harbour scenes, including *Sailing Ship* (page 23), from 1815, and *View of a Harbour*, from 1815/1816 (pages 64/65). Like his landscapes, most of these marine scenes were composites of drawings sketched at various times and were not meant to be accurate representations of specific locations. The marine theme, with and without staffage, repeatedly occupied him, culminating in one of his late masterpieces, *The Stages of Life* (pages 108/109).

While staying in Greifswald Friedrich was approached for his ideas regarding the design of a new altarpiece for the town's St Mary's

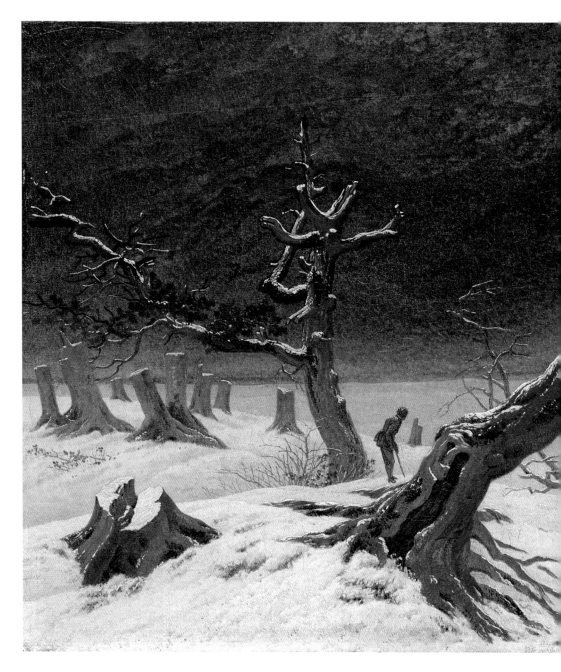

Church (Marienkirche). The fourteenth-century church had been severely damaged during the Thirty Years' War. Philipp Otto Runge had been commissioned to paint the altarpiece, but since he had died the town council asked Friedrich to be involved. The scheme came to nought for lack of financing. The following year Friedrich wrote to the king of Saxony, Friedrich August I, applying for citizenship. This cannot have been an easy decision given Saxony's enforced alliance with France against Prussia during the Napoleonic Wars and the Prussian patriotism implied in his paintings. Nevertheless, citizenship was granted him and he was awarded a stipend as a member of the Dresden Academy.

In 1817 Friedrich met the physician Carl Gustav Carus (1789–1869), who became a friend and pupil. The two took various trips together in Bohemia and Saxony. Carus was a gifted amateur artist and his paintings echo Friedrich's style. As the author of *Nine Letters on Landscape Painting*, written between 1815 and 1824 and published in 1831, Carus is a valuable source for an understanding of Friedrich's œuvre and German Romanticism in general. He argued that landscape painting should not be merely imitation of nature, but a reflection of the artist's creative spirit. In one of the later letters Carus coined the term *Erdlebenbildkunst* (earthly life painting). Ideally a painted landscape should both capture the harmony of the given scene and inspire a mystical appreciation for the natural world.

Carus's book was doubtless indebted to his many conversations with Friedrich about art and

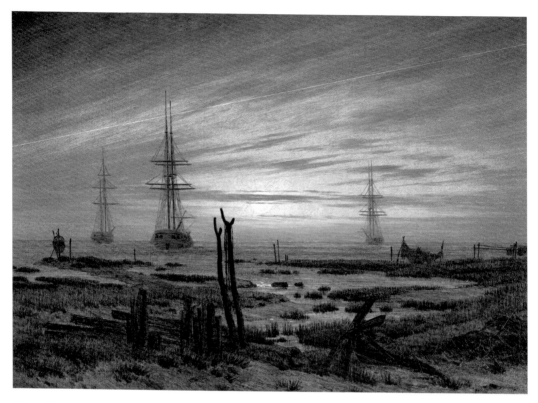

Ships at Anchor, c. 1817

the natural in the years of its writing. The idea that a painting's viewer should be moved to a spiritual contemplation of nature would seem to be realised in Friedrich's frequent use of the *Rückenfigur*, or figure seen from the back, from 1817 on. Such figures facing the grandeur of a natural scene serve as stand-ins for the viewer, inviting him to share in their exaltation. The first of these are seen in *Moonlit Seashore with Fishermen* (pages 66/67) and in what is surely Friedrich's most famous painting, *The Wanderer above a Sea of Mist,* from 1817/1818 (pages 68/69).

At the age of forty-three, in January 1818 Friedrich married Caroline Bommer, his junior by nineteen years. At the time Carus noted that Friedrich's bouts of melancholy became less frequent and his palette became lighter and less sombre. An early painting of Caroline, interestingly pictured as a *Rückenfigur*, is *Woman in Front of a Setting (or Rising) Sun* (pages 72/73), a picture full of optimism. It suggests that thanks to a woman after many years as a bachelor he has perhaps finally found his way towards the light of God. This is indicated in several of his paintings from this

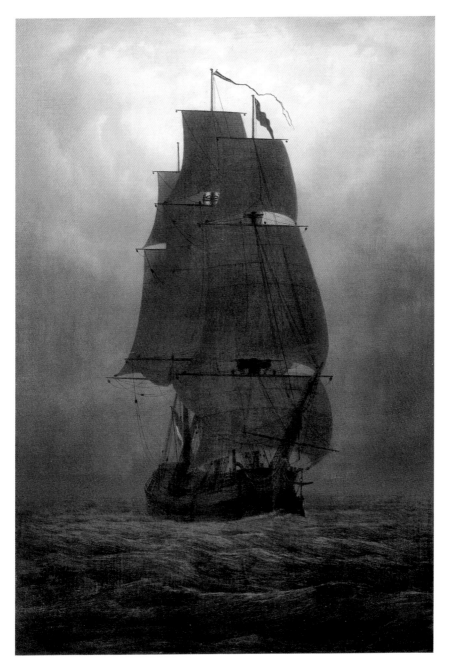

Sailing Ship, c. 1815

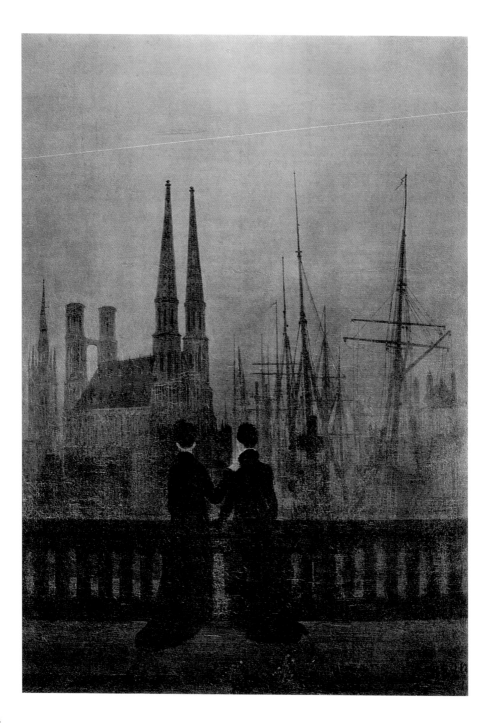

time that feature one or two women. The couple honeymooned in the summer at Greifswald, and most notably on the island of Rügen, where they were joined by his younger brother Christian. The painting *Chalk Cliffs on Rügen* (pages 78/79) depicts the artist and his wife, with Christian looking thoughtfully out to sea. This painting, together with *The Wanderer*, are perfect examples of Friedrich's embrace of the sublime as an aesthetic. Later in 1818 Friedrich met the theologian and philosopher Friedrich Schleiermacher (1768–1834), the 'father of modern liberal theology', who suggested that the essence of religious experience was neither thinking nor acting, but intuition and feeling, and, as Friedrich later commented, 'A painting should not be invented but felt'. Friedrich's *Two Men Contemplating the Moon*, from 1819 (pages 80/81), may well be a direct response to this. The painting is one of several that picture the *Rückenfigur* studying nature, and may well be autobiographical. The other figure in the painting is possibly another of Friedrich's pupils, August Heinrich (1794–1822).

The Norwegian artist Johan Christian Dahl (1788–1857) settled in Dresden in 1818 and was mentored by Friedrich. Like Friedrich, Dahl had received his training in Copenhagen, and they had similar ideas about the study of nature and the presentation of spiritual values in landscape painting. Dahl also created imaginary landscapes combining motifs from separate sketches. Friedrich, Carus and Dahl would be remembered as the three exemplars of German Romantic painting in Dresden.

Beginning in 1819 Friedrich moved away from the evocation of the sublime in favour of a more introspective style. This was probably a result of his association with Carus and Dahl and his new contentment as a newlywed. A marked difference can be seen in his painting *Woman at a Window* (pages 90/91), from 1822, a portrayal of his wife Caroline, again as seen from the back, but this time in an interior setting. The symmetry of the composition and the room's ascetic quality suggest a move towards a visual interpretation of Goethe's Weimar Classicism in literature, which sought to fuse aspects of Classicism (symmetry) and Romanticism (subjectivity). *Garden Arbour in Moonlight* (pages 84/85) is another symmetrical composition.

Although most of his landscape paintings after this time appear to be more conventional, like *Village Landscape in Morning Light* (pages 92/93), they are in fact imbued with spirituality. This painting is subtitled *The Lone Tree*, with reference to the solitary oak that serves as the picture's focal point. The oak tree has always been a symbol of the German nation, so the painting can be considered a patriotic work. Oaks are featured in many other Friedrich paintings, for example in the earlier *Dolmen in Snow* (pages 46/47), where the trees form a protective ring around the burial mound, *Abbey in the Oakwood*, from 1809/1810 (pages 52/53) and the *Oak Tree in Snow* (page 28), from 1829.

In the summer of 1819 the first of Friedrich's three children was born, a daughter named Emma. He had also acquired two new patrons for

Meadows near Greifswald, c. 1820–1822

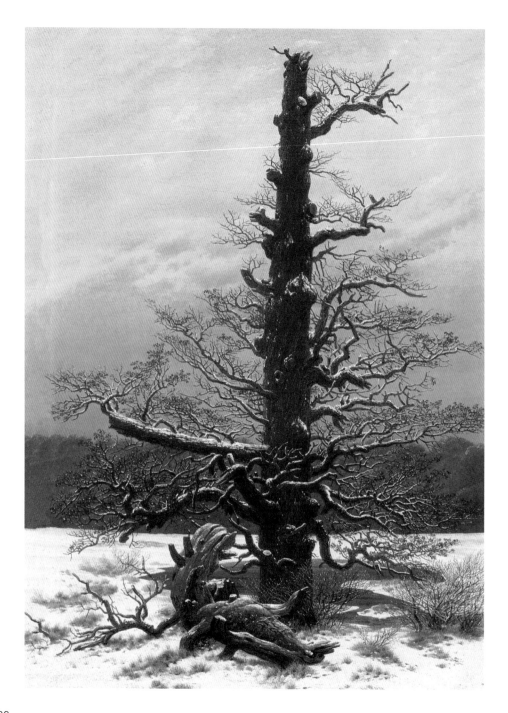

Oak Tree in Snow, c. 1829

his work at this time, the publisher Georg Andreas Reimer (1776–1842) and Prince Christian Frederick of Denmark (1786–1848). Unfortunately, the same year saw the 'persecution of the demagogues' within the German Confederation; the Carlsbad Decrees were an attempt to quell growing sentiment for German unification. The persecution was particularly punitive in Prussia, where all liberal thought was being expunged.

In 1807 and 1808 the natural scientist and philosopher Gotthilf Heinrich von Schubert (1780–1860) repeatedly delivered a lecture titled *The Dark Side of the Natural Sciences*, using Friedrich's cycle of the seasons in sepia from 1803 as a visual aid. He wished to demonstrate the idea that these images of the seasons were analogous to the 'stations in a cultural history of our nature', that is the four stages in human life, and that they also represent the four successive stages in our relationship with nature. Children are essentially more at one with nature, but as they grow older they become alienated from it owing to societal pressures and do not return until they are in their dotage, looking forward to a 'new spring' in the afterlife.

In the autumn of 1820 Friedrich returned to this theme in a cycle of oil paintings with the titles *Morning, Midday* (page 30), *Afternoon* (pages 86/87) and *Evening*. Two years later he also produced single portrayals of times of day, not a complete cycle but the companion pieces *Village Landscape in Morning Light* (pages 92/93) and *Moonrise over the Sea* (pages 88/89).

By then Friedrich enjoyed the additional patronage of Grand Duke Nicolas (later Tsar Nicolas I)

(1796–1855) of Russia, who had visited him at his studio in 1820 with his new wife Princess Charlotte of Prussia (1798–1860). They were accompanied by the poet and writer Vasily Zhukovsky (1783–1852). On that first visit the future Tsar purchased *On the Sailing Boat* (pages 76/77) as a gift for his bride. He also bought *Sisters on a Balcony by the Harbour* (1820; page 24). These works, subsequently displayed at the couple's summer residence Peterhof, were the first Friedrich paintings to be purchased by a foreign buyer. Zhukovsky later revisited Dresden several times, buying paintings for the Tsar and for himself, for example *Moonrise over the Sea* and *Evening Landscape with Two Men*, from 1830–1835. During one of Zhukovsky's visits to Friedrich's studio he may well have seen *Swans in the Reeds* from 1819/1820 (pages 82/83), for in 1832 Friedrich painted a variant, *Swans in the Reeds by Dawn's Early Light*, which he sent to Russia along with several other small paintings in 1835.

In 1815 the *Essay on the Modification of Clouds* (1802) by the Englishman Luke Howard (1772–1864) was translated into German. It was essentially the first taxonomy of cloud formations, one still in use to this day. The text was enthusiastically endorsed by Goethe, who subsequently wrote poems on the subject and commissioned Friedrich to paint a series of cloud formations based on them. Friedrich, doubtless still smarting from the great writer's earlier criticism of him, declined, but in 1824, probably at the suggestion of Johan Dahl, he executed some cloud studies on cardboard, such as *Evening* 1824 (pages 32/33). Coincidentally,

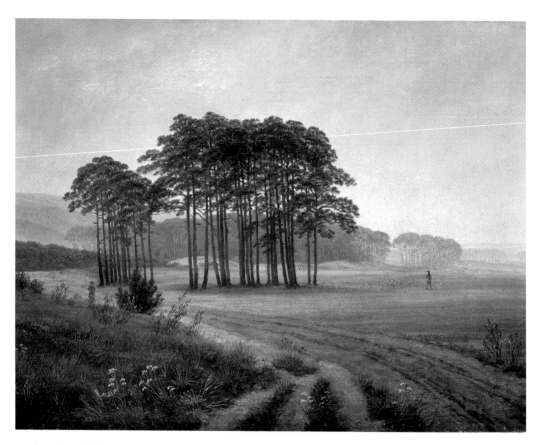

Midday, c. 1820/1821

Friedrich's near contemporary the English Romantic painter John Constable (1776–1837) was also executing oil sketches of cloud formations on board at this time in preparation for his larger 'six-footer' paintings. Friedrich had already produced several full-size paintings featuring the ethereal qualities of clouds and mist, for example *Mist in the Elbe Valley* (1821; opposite). Cloud formations would continue to be important motifs in his later work.

Prior to the arrival of Friedrich's second daughter Agnes in September 1823, his fellow artist Dahl moved into the family's large house in Dresden.

The two men were thus in constant contact and they both provided help for younger students who came for advice. In the same year Friedrich returned to a political theme with his painting *Hutten's Tomb* (pages 94/95), picturing an imaginary monument set in the ruins of an abbey.

In January 1824 Friedrich and Dahl were appointed adjunct professors at the Dresden Academy, but with no teaching duties. Friedrich had hoped to succeed Johann Christian Klengel (1751–1824) as director of the landscape class, but his application was rejected. Perhaps in response to that rejection Friedrich began to work on one

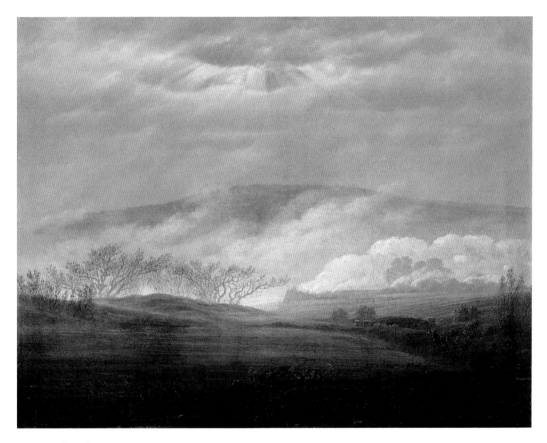

Mist in the Elbe Valley, c. 1821

of his most enigmatic and complex paintings, *The Sea of Ice* (pages 96/97), which even to twenty-first-century eyes seems strikingly modern. The painting eschews any notion of the sublime, for there is no provision for an awestruck viewer, no place for one to stand while gazing down onto the scene. Contemporary viewers were utterly bewildered by the painting.

In late 1825 Friedrich fell ill again and spent the next few months convalescing on Rügen, as he repeatedly did in the last fifteen years of his life. He now produced fewer paintings and no longer engaged with politics or the sublime.

Most viewers found his work to be outdated. His bouts of melancholy deepened and he became irascible, alienating Carus, once his closest friend and confidant. He distanced himself from his small group of students, and since his paintings were no longer selling he and his family suffered financially. His few paintings were more personal and reflective, more difficult to decipher. He became reclusive and rarely engaged with others, especially after suffering a stroke in 1835.

His most striking painting from this period was *The Large Enclosure* (pages 104/105). It was ahead of its time, anticipating such Neo-Romantic

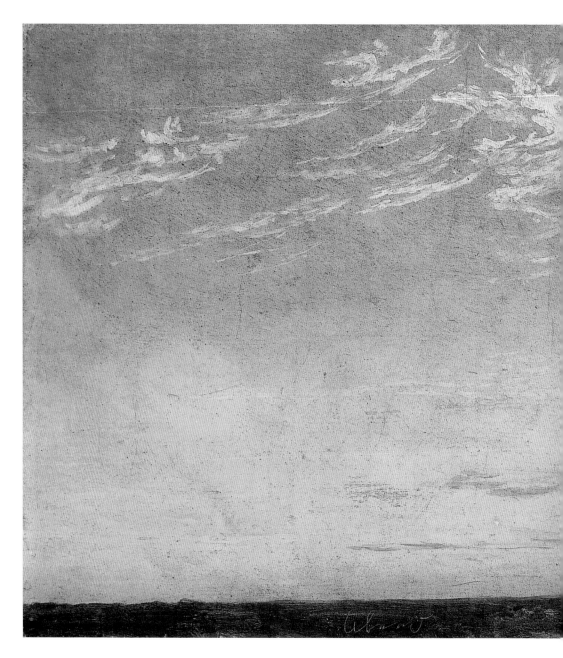

Evening, 1824

painters of the twentieth century as Paul Nash (1889–1946). In Friedrich's time its strange planar point of view and non-negotiable terrain made it a very difficult picture to comprehend. A pair of paintings executed in 1828, *Trees and Bushes in the Snow* (pages 102/103) and *Fir Trees in Snow* (opposite), are deeply contemplative works; faced with nature up close the viewer, with nothing to distract him, is forced to meditate on his own place in it. The snow has a calming influence, but it also symbolises the inevitability of death.

An oil painting that is more easily interpreted, painted between 1830 and 1835, is *The Evening Star* (pages 36/37), a composition similar to *Hill and Ploughed Field* from 1824 (pages 98/99) but with Friedrich's children almost in silhouette at the top of the hill. The three gothic spires correspond to the heights of the children, with Adolf flinging up his arms as if worshipping both nature and his faith. Perhaps this painting was the artist's *memento mori*.

After his last illness and the stroke that left him partially paralysed, Friedrich struggled to paint in oils and returned to his earlier medium of sepia in meditations on death such as *Graveyard in Moonlight* (pages 106/107). These late images document the artist's struggle with his own mortality and salvation. In these last years Friedrich suffered financially and had to be rescued by his loyal patrons. The Tsar not only bought some of his paintings, he also financed Friedrich's trip to the Bohemian spa town of Teplitz to convalesce following his stroke. Friedrich died in penury on 7 May 1840 and was buried in Dresden's Trinitatis Cemetery.

His painting had little influence on European art in the nineteenth century, but there were parallels in the works of the Hudson River School in the United States. That style was partially influenced by immigrant German artists, mainly from the Düsseldorf School. It was not until Berlin's Nationalgalerie mounted its *Centenary Exhibition of German Art 1775–1875* in 1906 that Friedrich's greatness was again recognised, some commentators seeing his work as very 'modern'. But many people outside of Germany had still not heard of Friedrich until a retrospective at London's Tate Gallery in 1972, at which the curator described him as 'the greatest genius of German Romantic painting'.

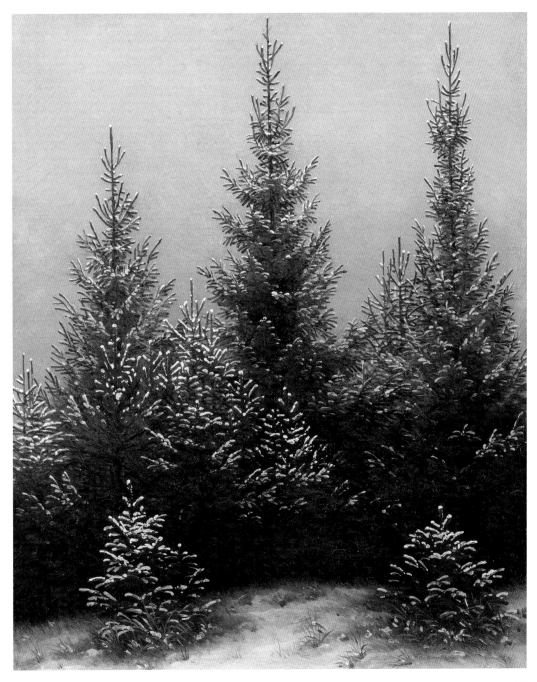

The Evening Star, c. 1830–1835

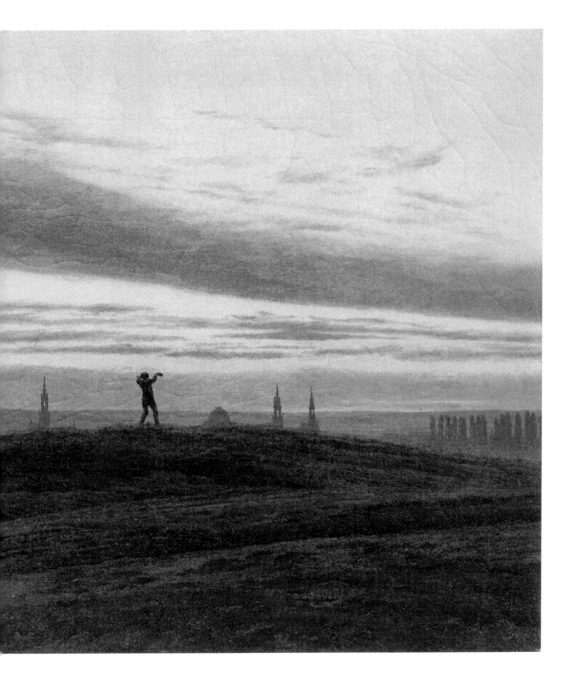

WORKS

Emilie's Spring in Copenhagen, 1797

Pencil, pen, grey ink, watercolour
22 × 17 cm
Kunsthalle, Hamburg

During his years of formal art education at the Copenhagen Academy, Friedrich spent many hours roaming the countryside around the city, sketching various motifs that would form the basis of his Romantic aesthetic. The *Emiliekilde* (Emilie's Spring) is a memorial to Emilie von Schimmelmann, the wife of a wealthy politician and nobleman, who died from tuberculosis in 1780 at the tender age of twenty. The monument, at nearly six metres high and set in a small garden close to the shoreline, had provided a motif for several artists before, including the Academy director Jens Juel. Juel was succeeded as director by the Neoclassical painter and architect Nicolai Abildgaard (1743–1809) who designed this monument. The addition of a poetic inscription dedicated to Emilie's memory, penned by the poet Christen Pram (1756–1821), added to the monument's elegiac qualities, and it became a very popular site to visit.

Friedrich's rendering was drawn from nature and is redolent of the English Picturesque style prevalent in Europe at this time. In essence an English garden landscape design presented nature as if viewed in a painting. In a Romantic movement context, the watercolour is closer to the 'beautiful' than the 'sublime'. Constituent parts of a 'picturesque' garden would be a focal point, such as a memorial, arbour, or small folly, a natural, rather than formal landscape, and wispy trees, and the scene would invite the viewer to map a path through it. There is however a marked departure from this aesthetic in Friedrich's work. The composition does not allow the viewer easy access into the space, because of the broken branches in the foreground. The sense of a subtle intent to disorient the viewer is a key feature in most of Friedrich's oeuvre.

This watercolour is one of four painted the same year, including the slightly larger work known as *Queen Louise Spring in Frederiksdahl*.

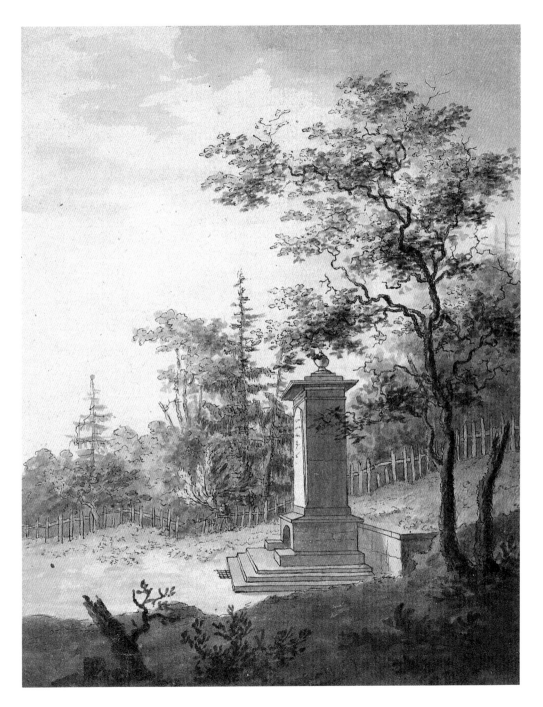

Winter, c. 1803

Brush, brown ink over pencil
19 × 28 cm
Staatliche Museen, Berlin

This sepia painting is the last of four depictions of the seasons of the year. The first, *Spring* (page 13), pictures small children playing in a field that is also occupied by lambs. It is a scene of freedom, joy, and the optimism of youth. This is followed by *Summer*, where the landscape becomes more open, reminiscent of a Claude painting, with a young couple sheltering from the sun. *Autumn* depicts an empty landscape with mist-covered mountains in the background to provide a sense of a chill in the air. Finally, the painting of *Winter* features an old man seated on the ground in front of a ruined monastery and surrounded by graves. From the bottom right the diagonal of the broken branch leads the viewer's gaze to the top of the ruin and heavenward, to man's salvation. A full moon is often seen as a harbinger of death, but can also be a sign of transition, in this case from life to death and back to life again.

Probably inspired by his friend Otto Runge, who had already completed the cycle *The Times of Day* (1802/1803), Friedrich was symbolising the transiency of life from cradle to grave, with *Winter* representing the possibility of a new spring in the afterlife. Such temporal images, either of the seasons or the times of the day, became an important theme for Friedrich throughout his career. Most of his paintings in fact show the transition between life and death, many of them less obviously than this one, but even at this stage Friedrich was using landscape to explore the idea of depicting the visible but alluding to the invisible. Asked why he repeatedly painted death, the grave and transiency in his work, he stated that he 'needed to submit himself to death many times in order to attain the everlasting'.

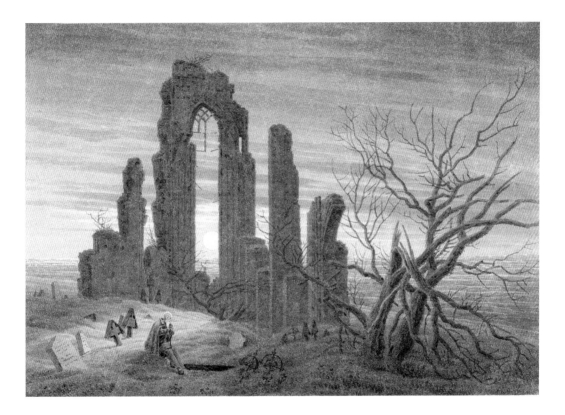

Pilgrimage at Sunrise, 1805

Brush, grey-brown ink over pencil
41 × 62 cm
Klassik Stiftung, Weimar

A breakthrough in Friedrich's early career came when this painting, together with its companion piece *Summer Landscape with Dead Oak,* was submitted to an exhibition in Weimar, the *Weimarer Preisaufgaben für bildende Künstler,* organised by Goethe and his friend Heinrich Meyer (1760–1832) to promote visual art. Through their journal *Propyläen* they offered a prize for a submitted painting based on the subject 'The Deeds of Hercules'. Despite the specificity of the theme, Friedrich submitted the two paintings with a cover letter to Goethe, who was so taken by the works that he awarded them a joint first prize.

Although Weimar was only a small grand duchy at the time, it was a very important cultural centre that attracted such luminaries as Goethe in what became known as the Golden Weimar era. Winning the prize was unexpected by Friedrich, who was merely trying to show his work outside of Dresden, and it resulted in appreciation for his work by a wider audience. For the next few years Friedrich continued to send work to Weimar for exhibition and sale. His large-scale sepia painting *Dolmen by the Sea* (1806/1807; page 17) was purchased by the ducal family.

The painting is very conventional in its compositional use of a path leading the viewer to and from the pilgrimage site, but ultimately he is required to stand at the picture's edge to view the cross – a somewhat disconcerting feature of the composition. Although Friedrich had used the symbol of a cross in his *Mourning* of 1799, and again in *The Ruins of Eldena with a Funeral* (1802/1803; pages 14/15), this is the first time the artist included a crucifix, a motif that became a hallmark of his later work. It was probably at this point that Friedrich decided to use landscape painting to document his religious faith and inward spirituality.

Dolmen in Snow, c. 1807

Oil on canvas
62 × 80 cm
Galerie Neue Meister, Staatliche Kunstsammlungen, Dresden

On his frequent visits to the island of Rügen Friedrich encountered these neolithic burial sites. They are found all across Europe, some of them up to seven thousand years old. Their origin is unclear, but the fact that they were 'otherworldly' was enough to stimulate Friedrich's imagination. The dolmen, which has now diminished in size due to erosion, is surrounded by three oak trees, important features in Germanic pagan mythology. The poor condition of the trees, particularly the rear one leaning backwards, creates a sense of abandonment, one heightened by the fact that the snow shows no sign of a human presence. The mist in the background also forbids viewers from looking into the distance, forcing them to confront the tomb itself and the transiency of life, while by its very presence it serves as a symbol of perpetuity.

A possible companion piece is *View of the Elbe Valley*, with the same dimensions and also dated c. 1807. Common to the two paintings are the lack of staffage and a group of rocks in the foreground – which in this case may, or may not, be a burial site – surrounded by fir trees. The fir tree is common in the region and came to symbolise the Protestant Christian faith through Martin Luther, who is said to have illuminated a fir tree with candles to celebrate Christmas. Friedrich used both firs and oaks extensively in his paintings.

This was possibly Friedrich's first oil painting, the medium and use of colour adding to the sense of solitude that expands beyond the picture frame and is evident from the untrampled snow contrasting with the trees and sky. The painting was originally purchased by Karl Schildener (1777–1843), a professor at Greifswald University and an early collector of the artist's work.

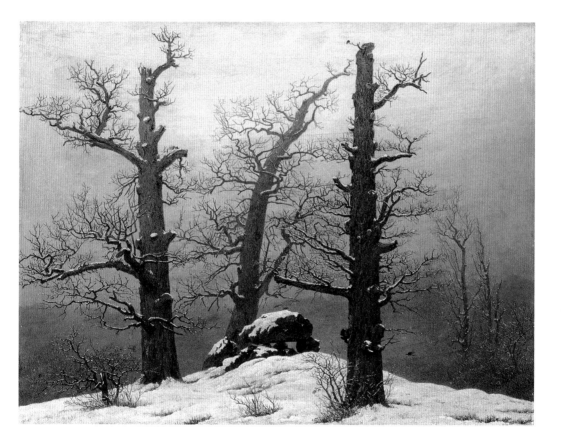

The Cross in the Mountains (Tetschener Altarpiece), 1807/1808

Oil on canvas
115 × 111 cm
Galerie Neue Meister, Staatliche Kunstsammlungen, Dresden

It is unclear who, if anyone, commissioned this work, but it was purchased by
Count Franz von Thun und Hohenstein (1786–1873) for his private chapel in Tetschen,
Bohemia, having previously been displayed in the artist's studio in Dresden
in December 1808. For the display Friedrich darkened his studio to create the
contemplative ambiance of a chapel. The painting met with a mixed reception
when shown, the fiercest criticism levelled by the art critic Friedrich von Ramdohr,
who was appalled that a landscape painting could be used as an altarpiece. He
feared that the artist had merged the worship of Christ with a worship of nature.
Nevertheless, the painting is now regarded as an exemplar of German Romanticism.
The work's frame was carved and gilded by a friend of Friedrich's, the sculptor
Gottlob Christian Kühn (1780–1828), with carved symbols of bread and wine,
representing the Eucharist, and a prominent Eye of Providence below. A predella
confirmed that this was indeed an altarpiece. However, the painting of the crucifix
breaks with traditional imagery, placing it quite firmly in a Nordic landscape,
while the figure of Christ is turned away from the viewer and faces the sun. The
great height of the cross emphasises its setting at the top of a mountain, which
accentuates the landscape rather than the crucifix. Mountain peaks are believed to
be where earth meets heaven.
There is also the possibility that the painting had political overtones. It has been
suggested by some historians that Friedrich, as a loyal subject, initially conceived
the work as a gift to King Gustav IV of Sweden (1778–1837), sharing his loathing of
Napoleon. Friedrich saw himself as half Swedish, and in 1824 named his son Gustav
Alfred.

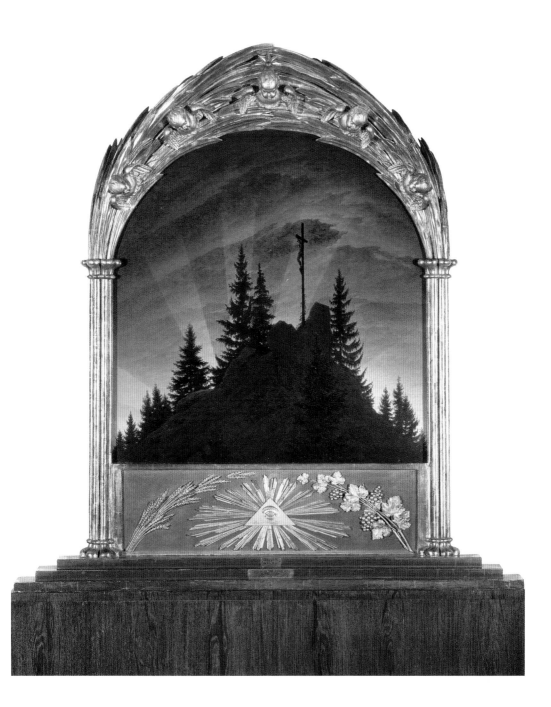

49

Monk by the Sea, c. 1808–1810

Oil on canvas
110 × 171,5 cm
Alte Nationalgalerie, Staatliche Museen, Berlin

Of the two paintings submitted to the Berlin Academy exhibition in 1810, *Monk by the Sea* attracted the most vociferous comments because of its barrenness and the lack of a traditional repoussoir, such as a pathway guiding the viewer into the picture space. Goethe was particularly scathing in his attack, suggesting that the work could just as well be viewed upside down. Friedrich's landscape is of course an allegory evoking the sense of isolation one feels as one tries to navigate his way through life, realising in the end that answers can only come from within. Originally the painting had some small ships in the distance, but clearly the artist felt that they were a distraction from the work's message, so painted them out. Although the work's title identifies the solitary figure as a monk, his lack of a head covering suggests that this is the artist himself as he struggles with life's problems.

This is the first of Friedrich's 'sublime' paintings, works evocative of the overwhelming grandeur and awesomeness of nature. The diminished figure, with hands clasped to his face, is surrounded by the unforgiving sea and a brooding sky. Friedrich's work was favourably reviewed by the writer Heinrich von Kleist (1777–1811) in an article published in 1810 in the *Berliner Abendblätter*: 'Never is one more wretched and forlorn than when faced with the world in such a way: the only spark of life in the endless realm of death, the solitary centre of an empty circle'. In essence Kleist viewed the painting as depicting the Apocalypse and marking a significant departure in Friedrich's œuvre. Probably his most telling comment was that when viewing the work's boundlessness, 'it is if one's eyelids had been cut away'.

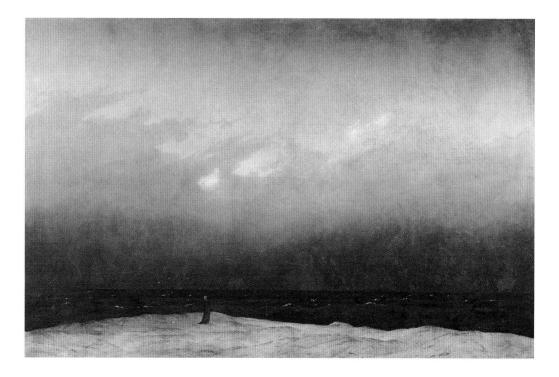

Abbey in the Oakwood, c. 1809/1810

Oil on canvas
110 × 171 cm
Alte Nationalgalerie, Staatliche Museen, Berlin

Always seeking new patrons for his paintings, Friedrich submitted two oil
paintings to the Berlin Academy exhibition in 1810, where they were warmly
received, and purchased by the king of Prussia, Friedrich Wilhelm III. *Abbey
in the Oakwood* was one, and the other was *Monk by the Sea* (pages 50/51).
The artist was promptly invited to become an external member of the
prestigious Berlin Academy. That is not to say that the pairing and the works'
subject matter were not criticised by the general public, some objecting to
their dark, melancholy mood. One thing that makes their pairing unusual is
that the composition of *Abbey in the Oakwood* is symmetrical, whereas that
of its pendant is not.
Abbey in the Oakwood depicts a procession of monks carrying a very large
coffin through the portal of a ruined abbey. Everything about the painting
is suggestive of death and its inherent solemnity. The ruins are identifiable
as those of the Eldena Monastery near Greifswald, pictured here as a shrine
surrounded by oak trees like the dolmen burials from previous millennia.
Old graves surround the ruins, along with a solitary leaning cross. In the
foreground is a freshly dug grave. The mist in the background prevents the
viewer from looking into the distance, suggesting the uncertainty of death
and the hope for salvation. The effect is enhanced by the barely visible waxing
moon in the sky, a reassuring symbol of Christ.
Although not part of a temporal cycle, it is clear that in this work Friedrich
equated seasons and times of day with the stages of a human life. This
painting and its companion piece still hang next to each other at the Alte
Nationalgalerie, Staatliche Museen, Berlin.

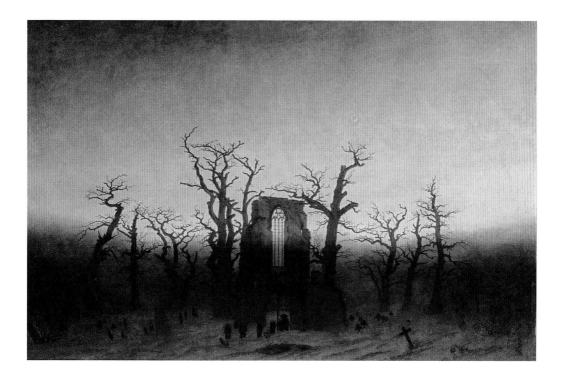

Mountain Landscape with Rainbow, 1810

Oil on canvas
70 × 102 cm
Museum Folkwang, Essen

In 1809 Friedrich executed a painting called *The Shepherd's Lament* (page 19), in which he incorporated a rainbow in accordance with Goethe's poem of the same name published in 1804. In every respect the painting follows a narrative similar to the poem's, and to all intents and purposes is a visual interpretation of the Weimar Classicism in literature. This may have been an attempt by Friedrich to ingratiate himself with Goethe and his circle, who had noticeably distanced themselves in the aftermath of the 'Ramdohr Affair' (pages 16 and 48).

In the following year Friedrich painted *Mountain Landscape with Rainbow*, a contrasting picture that is the essence of German Romanticism, with its brooding sky and abyss just beyond the foreground. The sun, which is behind the viewer, illuminates a lone figure, most probably Friedrich himself gazing at the majestic rainbow, a symbol of God's covenant with Noah, and by extension, mankind. The figure in the painting is therefore contemplating God's awesome Creation with reverence. The composition is however classical in concept, with the mountaintop centred between framing diagonals and the distances above and below the centre of the rainbow conforming to the golden ratio, as observed during the Renaissance. The additional light source, the moon, is semi obscured by dark clouds. Since normally the sun is the giver of life, and the moon can be interpreted as the harbinger of death, it can be inferred that Friedrich was here extolling a perfect harmony in nature that reflects the life cycle, and for man the *iter vitae*, or journey of life, here embodied in the lone figure, the wanderer. Both of these paintings were purchased in Weimar by the Grand Duke of Saxe-Weimar-Eisenach, Karl August (1757–1828), patron of Weimar Classicism.

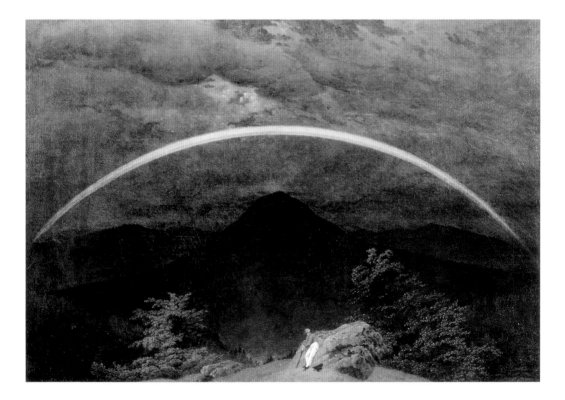

Morning in the Riesengebirge, 1810/1811

Oil on canvas
108 × 170 cm
Alte Nationalgalerie, Staatliche Museen, Berlin

In the early months of 1810 Friedrich visited the Riesengebirge, a range of mountains in the northern part of Bohemia (now Czech Republic). Despite the criticism Friedrich received concerning *Cross in the Mountains*, the artist returned to the theme of a cross within a landscape in *Morning in the Riesengebirge*. Unlike the *Tetschener Altarpiece* (pages 48/49), this painting offers an unrestricted view of the entire landscape. The crucifix is no longer the dominant feature, and the work is clearly not intended as an altarpiece. It is also notable that the Christ figure is no longer turned away from the viewer. Two climbers have just arrived at the shrine. These two figures, painted into the landscape by the artist's friend Georg Kersting, are unusual. The female is dressed in a flimsy white dress and holds out a hand to help a male figure dressed more appropriately for the terrain. The suggestion here is that the female figure is a spiritual guide or angel, while the male, possibly Friedrich himself, is being helped on his journey towards Christ the Redeemer, the intercessor between Earth and Heaven. This use of allegory is more likely than the literal alternative, since there appears to be no navigable route to the summit.

The painting is a prime example of Friedrich's use of an amalgam of pictorial references made in his sketchbooks, since the actual view does not exist. It is known that the boulders and rocks, for example, are from different sketches he made while in the Riesengebirge, while other features are from much earlier sketches. King Friedrich Wilhelm III of Prussia purchased this painting in 1812, possibly together with its companion piece (now lost) depicting a ship navigating a river, and a man helping a woman to climb a ravine.

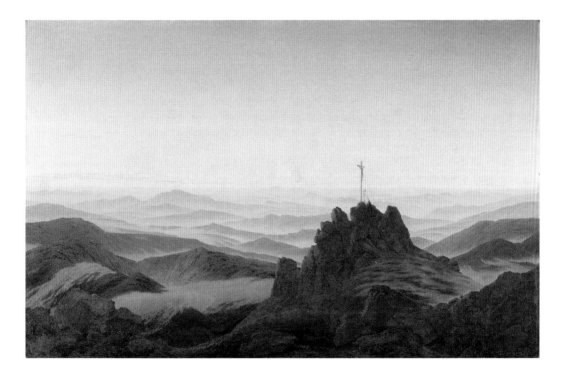

Winter Landscape with Church, 1811

Oil on canvas
33 × 45 cm
National Gallery, London

In his essay *On German Architecture*, written in 1773, Goethe waxed lyrical about the Gothic style of architecture, and how it had been an integral part of Germanic culture since the Middle Ages. This was based on his visit to Strasbourg, where he encountered its organically fashioned cathedral, which he likened to 'a far-spreading tree of God, with its thousand branches, millions of twigs [proclaiming] everywhere the glory of God'. As a close follower of Goethe's writing, Friedrich executed his *Winter Landscape with Church* to illustrate these ideas. The varying heights of the fir trees mirror the Gothic spires in the distance, the snow symbolising death. Unlike the tangible fir trees, the church in the background is indistinct and ethereal. There are thus two zones in the picture, one earthly, the other spiritual. A notable gateway spans the two spaces, but in order to gain access, it has to be through Christ the Redeemer, depicted as a shrine in the middle distance.

The painting has to be seen with its companion piece *Winter Landscape* (pages 20/21), a painting of a bleak, snow-covered terrain with barren oak trees and tree stumps representing death, to establish the narrative of both works. The viewer is meant to see this other work first. The use of oak trees, already seen in Friedrich's depictions of ancient burial sites, suggests that the crippled figure in the centre of the composition is pagan and, fearing imminent death, seeking salvation. This redemption comes when the crippled man, his crutches abandoned in the snow, is seen at the foot of a bright crucifix among the fir trees in *Winter Landscape with Church*. It is of course important that the trees are evergreens, symbolising Christ's eternal redemption of mankind.

This picture was the first Friedrich oil painting to be purchased and displayed in a British public collection.

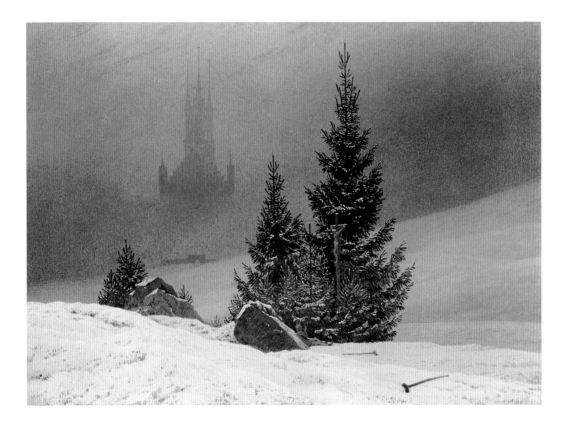

Tombs of Those Fallen
in the War of Independence
(Tombs of Ancient Heroes), 1812

Oil on canvas
49 × 70 cm
Kunsthalle, Hamburg

This painting is one of the few overtly political and patriotic works by Friedrich.
It was exhibited in the capital at a time when Prussia was forced to cooperate
with Napoleon's planned invasion of Russia. Friedrich was vehemently opposed
to Napoleon and equally disappointed that Prussia was involved. The painting can
therefore be seen as both anti-French and critical of the Prussian king.
The viewer is staring downward towards a cave, with two French chasseurs at its
entrance, as the occupying force. The figure on the left is looking back towards
the viewer, perhaps fearing for his life, since the rugged terrain of the gorge
would be difficult to escape from if attacked. On either side are two large tombs
with legible inscriptions. On the left-hand sarcophagus is the inscription 'Friede
deiner Gruft/Retter in Noth (Peace be to your grave/Saviour in our time of need)',
while the right-hand one reads "des edel Gefallenen für Freiheit und Recht. F.A.K.
(Of the nobly fallen in the cause of freedom and justice)'. These are references
to earlier conflicts with Prussia, possibly the Silesian Wars in the previous
century. A more recent memorial in the form of an obelisk appears left of centre,
commemorating German losses in the Napoleonic Wars. The inscription reads
'Edler Jüngling Vaterlandserretter (Noble Youth, Saviour of the Fatherland)'. Also
appearing on the monument are the initials GAF, probably referring to those who
had fallen and risked censorship by the French occupying force. In the foreground
is a broken tomb, with reference to Arminius (18 B.C.–A.D. 20), the Germanic hero
who fought against the Romans in the first century.
Since the painting is relatively small, Friedrich intended that the viewer,
examining the work close up, would become totally immersed in its meaning.

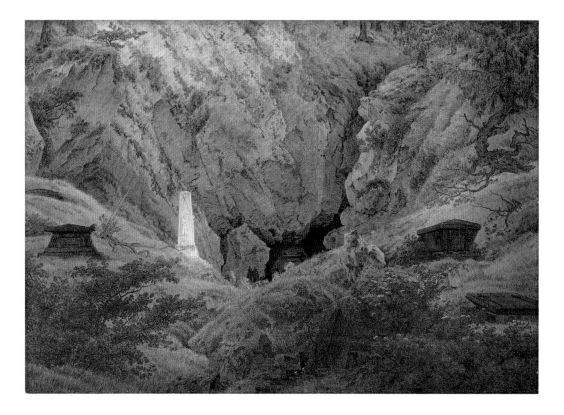

The Chasseur in the Woods, c. 1813

Oil on canvas
66 × 47 cm
Private collection

In a departure from his normal practice, for this work Friedrich chose a
vertical format. This emphasises the height of the dark forest as compared to
the diminutive figure in the foreground. The V shapes of the skyline and the
outline of the fallen snow add to this verticality. Painted at the time of the
occupation of Dresden by Napoleon's forces, it depicts a lone French cavalry
officer contemplating his fate after having been separated from his horse.
Because of the viewer's line of sight, it is impossible to determine what the
soldier can be looking at. This is probably the point of the picture, an indication
that the soldier's future is unknown. The raven and the tree stump are both
portents of death, as is the snow, brilliantly illuminated in contrast to the dark,
sinister background. The inclusion of evergreen fir trees, symbolic of Germanic
tradition, suggest Friedrich's trust in the permanence of a German state to
come.
The painting was shown in Dresden in an exhibition of patriotic art following
the defeat of Napoleon in 1814, but was not easily understood at the time
because of the puzzling presence of a French soldier in a Germanic landscape.

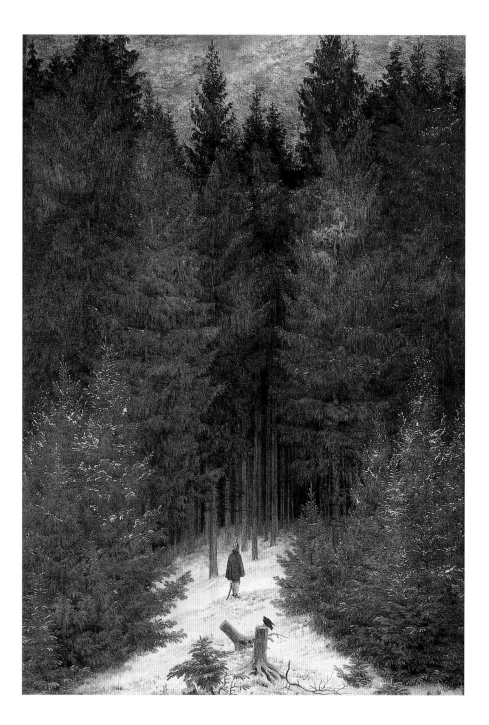

View of a Harbour, 1815/1816

Oil on canvas
90 × 71 cm
Stiftung Preussischer Schlösser und Gärten, Berlin-Brandenburg

Disappointed with the outcome of the Congress of Vienna and the conservatism of the resulting Confederation, in the fall of 1815 Friedrich left Dresden, accompanied by the musician Friedrich Kummer (1797–1879), on a visit to his native Greifswald and the island of Rügen. For the time being, at least, Friedrich moved away from political and patriotic themes in his work, embarking on a series of more conventional landscapes and harbour scenes such as this one. The indefiniteness of the location is quite deliberate. As with his landscapes, the composition is an amalgam of sketches; it was intended to draw the viewer into a scene of tranquillity and peace and stimulate spiritual thought. In this case the ships and small boats probably symbolise the 'journey of life', a theme he returned to time and again.

The scene is set at dusk, with a very faint waxing moon in the sky between the masts of the two tall ships. In some Christian traditions a waxing moon represents Christ. The variously coloured sky applied with very thin washes and glazes generates a dynamism in the scene, creating the illusion that the ships have either just arrived or are about to sail. Friedrich enhanced the illusion with the two main ships in the foreground facing in opposite directions. The rowboat in the foreground with two oarsmen and a pilot is taking a couple on their outward journey, away from earthly existence, represented by the harbour, towards their salvation in the afterlife, the invisible beyond the horizon.

The painting was purchased by King Friedrich Wilhelm III of Prussia in 1816 at the behest of his young son, Crown Prince Frederick (1795–1840), who had been advising his father on art purchases since the age of sixteen, when he purchased *Monk by the Sea*.

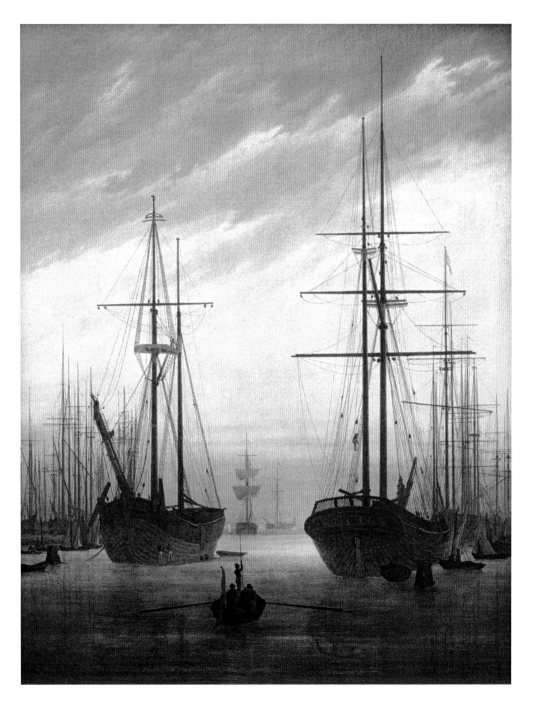

Moonlit Seashore with Fishermen, c. 1817

Oil on canvas
21 × 30 cm
Private Collection

Probably following discussions with his pupil and friend Carl Gustav Carus, Friedrich began to explore the idea of using the figure seen from the back as a motif in his paintings, beginning with *Moonlit Seashore with Fishermen*, picturing two men looking out to sea. In this work the viewer is invited into the picture space, to join the fishermen contemplating a cloudy grey sky illuminated by a full moon. This phase of the moon is often related to death, but can also symbolise transformation, reflecting perhaps Friedrich's newfound optimism and creativity following the final defeat of Napoleon.

The use of the *Rückenfigur* (figure seen from the back) dates back to the early Renaissance, when it was always used sparingly for ancillary figures, such as those in Giotto's *Lamentation of Christ*, or more openly by Johannes Vermeer (1632–1675) in his *The Art of Painting* (1666). However, it is Friedrich who is remembered for using the motif in several of his paintings and making it a hallmark of his work. The small sailing ships darting in different directions in the background appear to be leisure craft, enjoying a warm summer evening, while the two figures, and by extension the viewer of the painting, look on.

Although the painting has a companion piece of similar size, *Ships at Anchor* (page 22), there is little correlation between the two images, either aesthetically or spiritually. In fact, they are seemingly without narrative and are in complete contrast to each other. *Ships at Anchor* has no staffage and depicts three large sailing craft at anchor in the distance. Close to shore are two small rowboats on stands out of the water, which is at low tide. Not all of Friedrich's companion pieces exhibit an implied or real relationship to each other as he sought new ways of seeing.

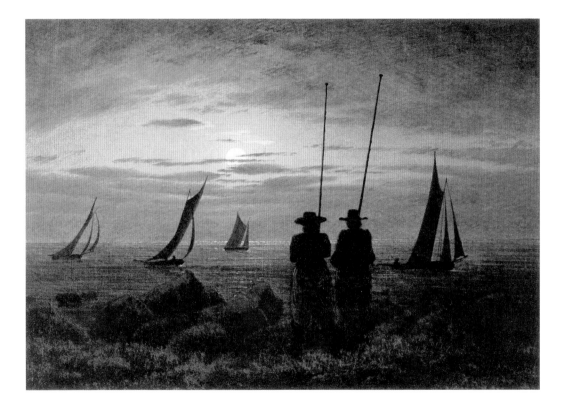

The Wanderer above a Sea of Mist, c. 1817/1818

Oil on canvas
95 × 75 cm
Kunsthalle, Hamburg

Arguably Friedrich's most famous painting, this composition is an amalgam of sketched drawings from his visits to various mountain ranges. The *Rückenfigur* is generally regarded as a self-portrait, standing on top of a rocky crag and gazing into infinity. He is wearing the traditional green *altdeutsche Tracht* (traditional German attire) – at the time seen as radical and later, illegal – proclaiming his belief in a unified and democratic Germany. The tall-format composition is symmetrical, with the figure centrally placed. The middle ground is a sea of fog punctuated by rock peaks, while the distance is a hazy mountainscape leading to infinity. At first glance the image fulfils the criteria for a 'sublime' painting, the Burkean 'terror' facilitated by the infinity created by the obscurity of the fog. Yet the viewer is not confronted by danger, as in the *Chalk Cliffs on Rügen* (pages 78/79). In fact, the *Rückenfigur* appears anchored to the rock, his legs and walking stick forming a rigid tripod that actually blocks the view of the landscape, emphasised by the verticality of the painting. By this means, the viewer is prevented from being the figure's proxy in the sublime experience, he can only guess the figure's sensations. This individual interpretation of the sublime is a unique feature of Friedrich's paintings, one originally derived from the Kantian idea of the 'noble' as sublime. Hence Friedrich's *Rückenfigur*, here and in many of his later paintings, cannot be a conduit to the sublime experience.

A short time after the painting was executed, this feature was noted by the artist's friend Carl Gustav Carus in his *Nine Letters on Landscape Painting*: 'Stand upon the summit of the mountain, and gaze over the long rows of hills. Observe all the magnificence that opens up before your eyes; and what feeling grips you? It is a silent devotion within you. Your I vanishes, you are nothing. God is everything'.

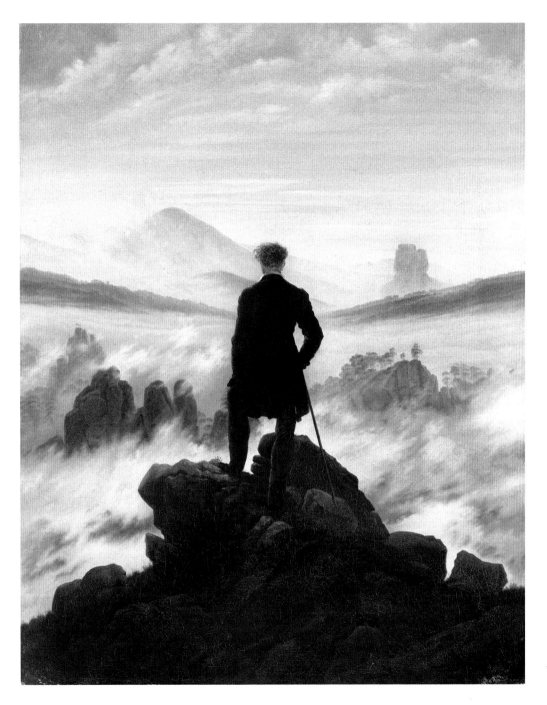

The Marketplace in Greifswald with the Friedrich Family, c. 1818

Pen, grey ink, and watercolour
54 × 67 cm
Pommersches Landesmuseum, Greifswald

Despite switching to the use of oil in about 1807, Friedrich occasionally worked in his original water-based medium, as in this example. Its bright luminous feel contrasts with his melancholy oils, suggesting that the city, with its familial ties, had a special place in his heart. It was painted on the occasion of his honeymoon. On his way to Rügen he had stopped here to introduce his wife Caroline to the Friedrich family and show her his birthplace. Of his four older brothers, three remained in Greifswald in adulthood and they are depicted in the centre of the composition, with the artist as seen from the back. The others were Christian Adolf, Heinrich, with whom he stayed during his visit, and Samuel.

The painting depicts the marketplace at Greifswald with a view down the Lange Strasse towards the Fish Market, a view that has changed little today. Beyond the Fish Market on the same street was the artist's childhood home, which is now the Caspar David Friedrich Centre. On the left of the painting is the city hall with its distinctive volute decoration on the façade and dating originally from the fourteenth century but given its present brick Gothic look in the eighteenth century. Just behind the city hall is the hundred-meter-tall spire of the medieval Gothic church of St Nikolai, also built in brick, from the fourteenth century. The church was granted the status of a collegiate church when it was annexed as part of the founding of the University of Greifswald in 1457. Nearly all of the church's present wooden furniture was made by Christian Adolf Friedrich (1770–1843), an older brother of the artist. The other buildings in the picture are elegant former homes and places of business for members of the wealthy Hanseatic League.

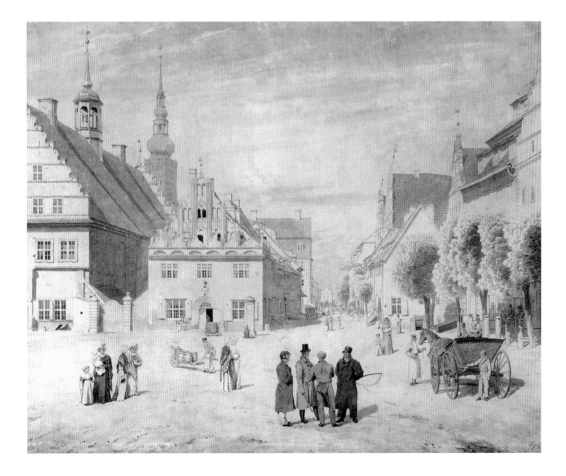

Woman in Front of the Setting (or Rising) Sun, c. 1818

Oil on canvas
22 × 30 cm
Museum Folkwang, Essen

In contrast to *The Wanderer,* Friedrich employed a more traditional landscape format for this work. It is also the first time that the artist depicted a woman as the *Rückenfigur*, and, like the wanderer she is monumental, which tends to prevent viewers from imagining themselves in her place. This is made manifest by the way the figure blocks the sun, whose rays emanate from her body as if she were a saint. This would suggest that the woman is in fact Friedrich's wife Caroline. Her outstretched arms appear to show that, like her husband, she is at one with nature. The width of the canvas at least allows the viewer to appreciate the warm glow of the sun indirectly as it illuminates the sky and distant hills. The painting's composition is more in line with traditional landscapes, as the viewer is able to study the entire landscape including the middle distance, which the artist normally obscures with mist or fog.

At the time he painted this picture, Friedrich's palette became lighter and fresher, particularly in paintings picturing his wife. Prior to his marriage Friedrich had led a very solitary life; the wife of one of his artistic friends referred to him as 'the most bachelor of the bachelors'. Friedrich the 'wanderer' is now no longer alone. The woman's gesture adds to the spirituality of the painting, her outstretched arms reminiscent of early Christian iconography, where the protagonist faces the viewer. In portraying her from the back Friedrich suggests that he does not want her to be seen as a specific woman, but rather a person seeking God through nature. This spiritual pantheism was a feature of German Lutheranism at this time and is alluded to by the inclusion of a church spire in the distance.

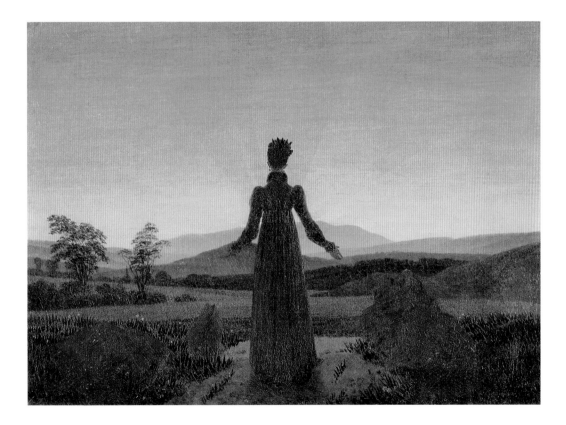

Woman by the Sea, c. 1818

Oil on canvas
21 × 30 cm
Kunst Museum Winterthur / Reinhart am Stadtgarten

The preliminary sketches for this painting were most probably executed during
Friedrich's several visits to the island of Rügen. In this painting he pictured
Caroline, again as a *Rückenfigur*, probably near the small fishing village of Vitt,
looking towards Cap Arkona in the distance. It is assumed, however, that the
portrait was added at the time of the painting's execution in the studio. It is also
probable that the figure was painted in by Friedrich's friend Georg Friedrich
Kersting. Because of the importance of the island to Friedrich for its natural
beauty as a motif and as a spiritual sanctuary, the artist was very keen to show
Rügen to Caroline during their honeymoon, and perhaps more important to
depict her in its landscape.

Friedrich first visited the island in 1801 accompanied by his drawing master
Quistorp, and it is entirely possible that at that time he met Ludwig Gotthard
Kosegarten, who was already famed as a poet and theologian. At Vitt Kosegarten
gave shore sermons to the fishermen unable to visit the nearest church in
Altenkirchen, five miles away, because of their work. Eventually Kosegarten was
able to build a small chapel in Vitt to extend his work. It is known that Friedrich's
earlier painting *Dolmen in Snow* (pages 46/47) was inspired by Kosegarten's
poem *Das Hünengrab* of 1798, and it seems likely that he was fully aware of
his sermons, which are more pantheistic than Christian, advocating that his
parishioners closely examine nature in order to reach and understand God.
For him, and by extension Friedrich, God was revealed in nature as much as in
scripture. Aside from Kosegarten, Carus was an equal influence on Friedrich's
pantheism, with his feeling that the artist should create a spiritual quest for the
viewer.

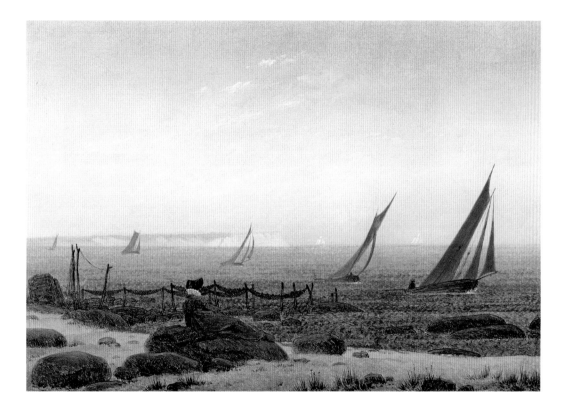

On the Sailing Boat, c. 1818–1820

Oil on canvas
71 × 56 cm
The State Hermitage Museum, Saint Petersburg

On the Sailing Boat has an altogether more secular feel in its approach, devoid of any obvious religious symbolism or allegory beyond its obvious reflection on the journey of life. The painting depicts Friedrich and his wife Caroline at the prow of a sailing ship returning from their honeymoon. The pink sky indicates that this is probably at sunset, perhaps an allusion to Matthew 16:2–3, where Jesus speaks of the fishermen's belief that a red sky in the evening bodes well.

The couple are holding hands as they gaze towards the sunset, full of optimism about their new life together. She is wearing a fashionable dress of the day, while he wears the Old German tunic complete with biretta, an endorsement of his nationalist aspirations. Again, they are both seen from the back, but this time the viewer is encouraged to stand in the foreground to enjoy the spectacle with them. However, the artist has used two devices to maintain a distance between the viewer and the couple, who are after all returning from their honeymoon. The first is the centrally placed mast, beyond which is an open hatch. The second is the sail blocking any approach on the right. Furthermore, the sailcloth resembles an unpainted canvas, as though Friedrich wants viewers to ignore that part of the painting. It is also a reminder that they are looking at a painting, not reality, though in his paintings he typically disguised any suggestion of brush strokes.

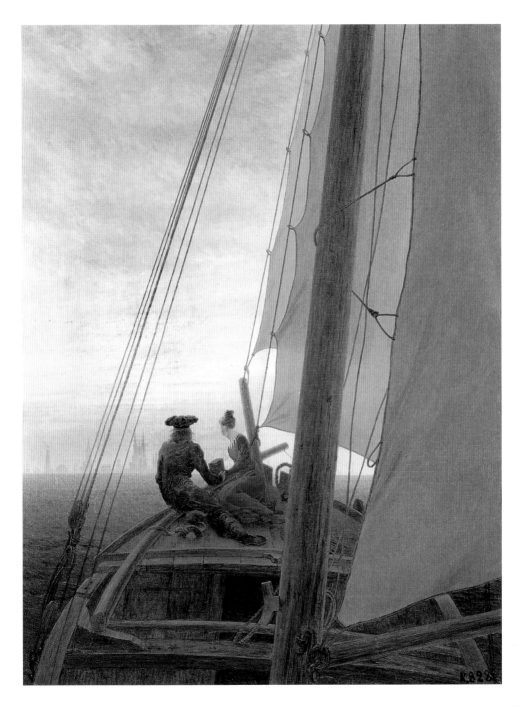

Chalk Cliffs on Rügen, c. 1818–1822

Oil on canvas
91 × 71 cm
Kunst Museum Winterthur / Reinhart am Stadtgarten

Following his marriage to Caroline Bommer in early 1818 Friedrich honeymooned in Greifswald and on the island of Rügen, at the southern edge of the Baltic Sea. *Chalk Cliffs on Rügen* is one of several paintings inspired by that trip. It was begun in 1818 and completed in 1822 and shows the artist kneeling and looking down at the cliffs, his wife Caroline hanging on to a tree trunk, probably distressed to see her husband taking such a risk, and possibly his younger brother Christian to the right looking thoughtfully out to sea. The composition is somewhat unusual for Friedrich, who normally has his figures contemplating the same spectacle. Here, although harmonious, each of the three looks in a different direction. The patriotic side of Friedrich's nature is noticeable in Christian's clothing, as he is wearing Old German attire, a costume that was subsequently banned by the conservative Confederation in 1819. Another interpretation identifies the figure on the right as Friedrich himself, demonstrating his nationalistic pride in Germanic culture as a younger man.
The location of the painting is, unusually for Friedrich, quite specific, and is identifiable as the famous lookout point at Stubbenkammer, on the tip of Rügen looking towards the Baltic Sea. Even so, Friedrich may well have taken liberties with the topography for a more dramatic effect. The trees appear to have been used to create a vignette. Once again Friedrich embraces the sublime aesthetic, depicting these three figures on the edge of a deep chasm. The main biographer of Friedrich and his work, Helmut Börsch-Supan, also suggested that the three colours used in the clothing, red (dress), blue frockcoat (Friedrich) and green (*altdeutsche Tracht / Old German attire*), equate with the Christian virtues Faith, Hope and Charity (Love), symbols of the artist's piety.

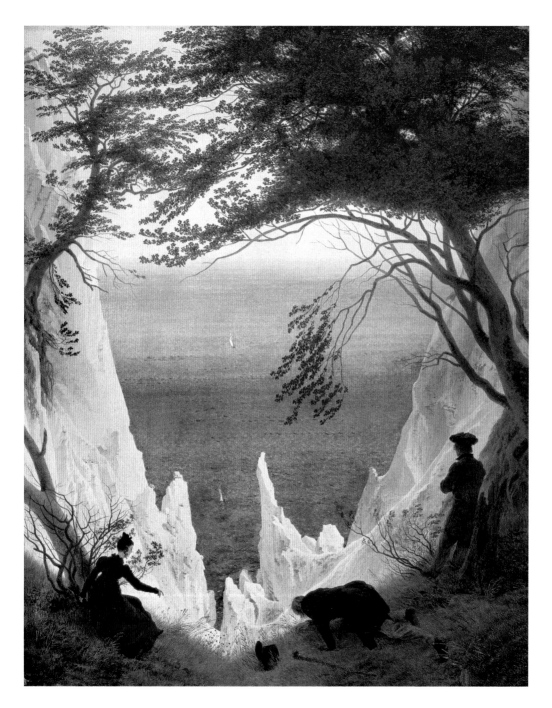

Two Men Contemplating the Moon, 1819

Oil on canvas
35 × 44 cm
Galerie Neue Meister, Staatliche Kunstsammlungen, Dresden

In the painting the two men, seen from the back, are staring into the abyss, a view that cannot be shared by viewers, whose access is denied by the rocks and trees. It is generally considered that the figure on the right is Friedrich and the other his pupil August Heinrich, both wearing the full *altdeutsche Tracht*. To their right is an uprooted dead tree, leaning against a large rock. As already noted, Friedrich had a penchant for dead trees in his work symbolising death, but this one still has foliage on the upper branches, suggesting that it is still clinging to life. It is known that Heinrich was frail and in poor health at this time and would die three years later. The frailty is alluded to as he is depicted leaning on Friedrich's shoulder. The waxing moon is a reminder of God's light in a world of darkness, and unlike the sun the moon in painting represented calm, particularly in its first phase.

The traditional German attire, known as the *altdeutsche Tracht*, was popular during the Napoleonic invasion of Prussia as a way of denoting German nationalism. It was worn in defiance of the French mode of dress, which was seen as frippery. Ernst Moritz Arndt (1769–1860), a leading nationalist born on the island of Rügen, was one of several advocates of the *altdeutsche Tracht*, but in the same year the painting was executed the costume was banned, with Arndt and others persecuted as 'demagogues'. This did not seem to deter Friedrich, who continued to picture the tunic in this and later paintings, observing rather dryly to one of his friends that in this painting the two men are 'plotting demagogic intrigues'.

Because of its popularity as a composition, Friedrich executed several versions of this painting, and others that included both men and women.

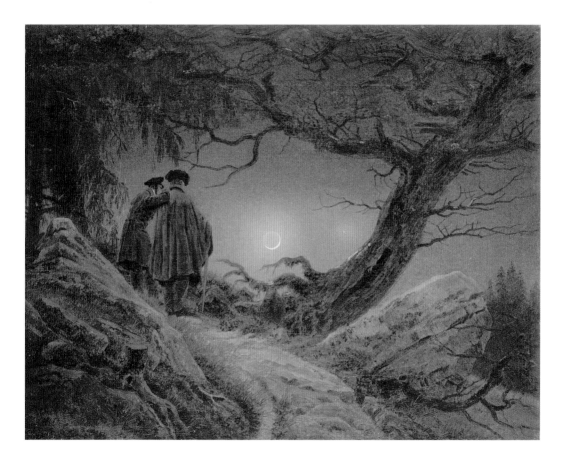

Swans in the Reeds, c. 1819/1820

Oil on canvas
36 × 44 cm
Freies Deutsches Hochstift/Goethe-Museum, Frankfurt am Main

Explaining his departure from traditional landscape, Friedrich allegedly remarked about this painting that 'The divine is everywhere, even in a grain of sand. Here I represent it in the reeds'. His remark, which may have been ironic, was made to the Nazarene artist Peter Cornelius (1783–1867), whose paintings on religious subjects evoke the aesthetic of the early Renaissance. Friedrich was insisting that nature has to be depicted as a divine creation, set against the artifice of human civilisation – an idea that originally came from Kosegarten. The appearance of the full moon in the centre of the composition can be interpreted as a harbinger of death. The focus of the painting is however the swans in the moonlight. Although it is a myth now dispelled, swans were said to 'sing' just before dying, as suggested here. The swan became a motif for a number of Romantic writers in the late eighteenth and early nineteenth century, culminating in the poem *The Dying Swan* of 1830, by Alfred Lord Tennyson (1809–1892). The swan was used as a motif by Friedrich on several occasions, as it was by his pupil Carus, who in 1852 executed a very similar painting for his daughter dying of typhus.
A motif of the Romantic movement in art and literature, in fact a leitmotiv, was the moon. The English painter J. M. W. Turner used it on many occasions, as did Friedrich. Goethe and the English poet Percy Bysshe Shelley (1792–1822) both wrote poems titled *To the Moon*, and in 1832, after the composer's death, the Piano Sonata No. 14 by Ludwig van Beethoven (1770–1827), composed in 1801, was dubbed 'the Moonlight'.

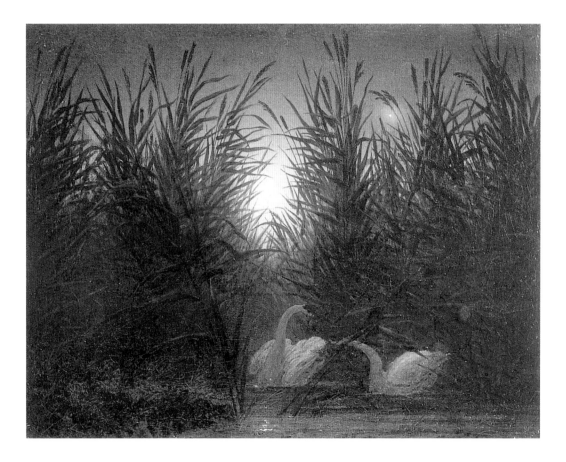

Garden Arbour in Moonlight (Memorial Picture for Johann Emanuel Bremer), 1820s

Oil on canvas
44 × 57 cm
Stiftung Preussischer Schlösser und Gärten, Berlin-Brandenburg

As in some of his earlier works, Friedrich here deliberately rejected the principles of garden design conventionally used in eighteenth-century landscape painting. The top of the picture is framed by an overhanging pergola, and the poplar trees beyond provide the verticals that make this a very symmetrical and rectilinear picture. The viewer is unable to negotiate the path to the illuminated city in the distance owing to the unusual angle of the view, the closed gate, and the river beyond. The presence of the moon adds to the emotional intensity, casting an eerie shadow in the foreground. The background is probably Greifswald, the masts of the tall ships on the right echoing the spires of the Gothic buildings in the centre so that they merge as one on the shoreline. This is a purely contemplative painting, signifying death and loss in the foreground, but with the promise of salvation in the background, with its red sky and cityscape reminiscent of the 'New Jerusalem' envisaged by the English Romantic poet William Blake (1757–1827).

The park in the foreground may well be a cemetery or memorial park, which is enclosed by formal gates. On the gates is the name Bremer, a reference to the physician and pharmacologist Johann Emanuel Bremer (1745–1816), in whose memory the painting was executed. Bremer was remembered for his work among the poor of Berlin and for the introduction there of the smallpox vaccine.

The idea of a memorial gate like this may have been inspired by a visit to Schloss Paretz, where Friedrich would have seen the memorial gate dedicated to the late Queen Louise, first wife of King Frederick Wilhelm III of Prussia.

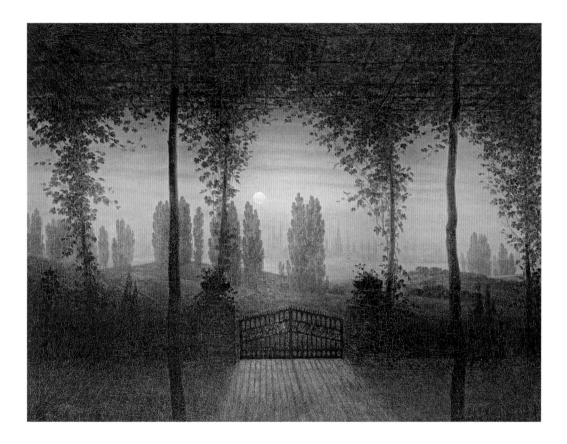

Afternoon, c. 1820/1821

Oil on canvas
22 × 31 cm
Landesmuseum Hannover

Revisiting the temporal cycle paintings he had begun in sepia in 1803, the artist executed four small landscapes in oil between 1821 and 1822, *Morning*, *Midday* (page 30), *Afternoon* and *Evening*. Conventionally, an artist would have used the same motif to depict the changing light over the course of the day, but Friedrich's differing topologies convey the mood itself, since the viewer is not distracted by comparing the same motif. Their small scale and diminutive staffage appear more akin to genre paintings, and unlike the previous cycles from 1803 this series does not appear to equate to the *iter vitae*, or journey of life.

Nevertheless, the paintings, although not allegorical, depict man's isolation, his presence in life diminished by the scale of nature around him. The size of the paintings requires the viewer to inspect them close up, looking for hidden symbols or allegories. Unable to find obvious clues, the viewer then realises he has to look within himself to find the meaning, that it is not an objective exercise but a purely subjective one. At this time the notion that landscapes could also be compared to music was aired by some critics, including Carl Ludwig Fernow (1763–1808), a member of the Weimar set around Goethe, and the Dresden-based philosopher Adam Müller (1779–1829), who wrote an essay titled *Something on Landscape Painting*, in which he likened music to landscape painting, pointing 'to the temporality of a pictorial composition'. He argued that to decipher a painting's true meaning the viewer needed to immerse himself in observation. It is this aspect that probably inspired Friedrich to paint this cycle, the only clues to their meaning being the titles themselves.

Moonrise over the Sea, 1822

Oil on canvas
55 × 71 cm
Alte Nationalgalerie, Staatliche Museen, Berlin

This painting was purchased by the German banker and arts patron Joachim Heinrich Wilhelm Wagener (1782–1861), whose collection formed the nucleus of Berlin's Nationalgalerie, where it now hangs. It has a companion piece, also at the gallery, *Village Landscape in Morning Light (The Lone Tree)* (pages 92/93). The paintings are totally disparate in mood and content. It cannot even be said that they are a contrast to one another beyond suggesting different aspects of the human condition. It is possible that they were initially intended as part of a cycle, but at this time Friedrich seems to have abandoned such series in favour of individual paintings suggestive of a transcendent mood like this one, but more especially separate landscapes.
Moonrise over the Sea is such a painting. Ostensibly it is an evening piece, but there are conflicting elements in the work. It pictures three people, a man (presumably Friedrich himself) and two women (one of whom is surely his wife Caroline), looking out to sea, awaiting the arrival of three ships coming in to shore and safety. Anticipation of their arrival is tempered by the melancholy achieved by the extensive use of violet on the horizon, which amplifies the rising full moon behind, a precursor of death, or at the very least, transition. Most of his paintings at this time show a transition between life and death, the tangible and intangible, that incline towards the unreachable. Accordingly, they often appear gloomy and mysterious.
The painting is possibly based on an earlier Friedrich work titled *Farewell* (1818), now lost, depicting a lone figure seated on a rock and waving a handkerchief at a ship sailing away into the distance, possibly on its last voyage.

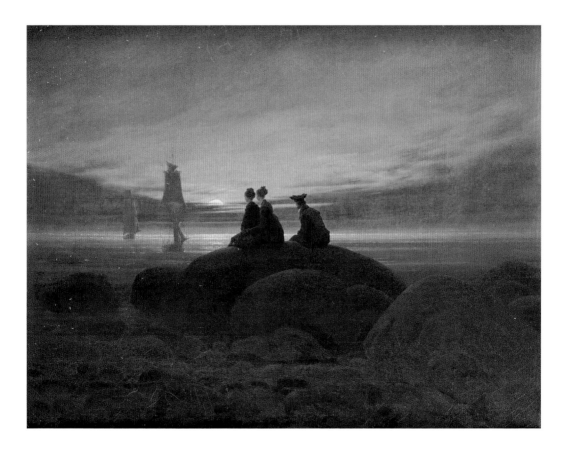

Woman at a Window, 1822

Oil on canvas
44 × 37 cm
Alte Nationalgalerie, Staatliche Museen, Berlin

One of Friedrich's few oil paintings of an interior is *Woman at a Window*, a portrait of his wife. The setting is the artist's studio overlooking the river Elbe. The religious symbols, such as the cross in the clear glass and the garden in the distance representing paradise, are obvious, while the gloomy interior represents the terrestrial world. His use of poplar trees was probably not by chance, since they symbolise a connection between the terrestrial world and the afterlife, while also recalling those who have already departed. As with so many of Friedrich's portrayals of figures seen from the back, the viewer of the painting is prohibited from enjoying the same view by the woman's presence. As she leans slightly to the left to look out the window, the viewer is once again barred from the scene by the upright mast of the passing ship. Although Friedrich and his family had moved in 1820, after the birth of their first daughter, this is not a domestic scene. There are no decorative elements normally associated with a domestic interior of the time, and there is no sense that this is a genre picture. It is known that Friedrich lived a very spartan existence until his marriage, as evidenced in the studio portrait by Kersting of 1812 (Frontispiece), and this painting would suggest that he continued to later, despite the fact that he was well known as a painter and comfortably off. In his paintings of his wife she always appears dressed in fashionable town clothes.

An interesting comparison can be made with an earlier painting, *Garden Arbour* (c. 1818), depicting two women facing away from the viewer in contemplation of an ethereal Gothic church. The arbour acts as a window frame, with both women looking through it, but there is a specific gap between them that allows the viewer to participate.

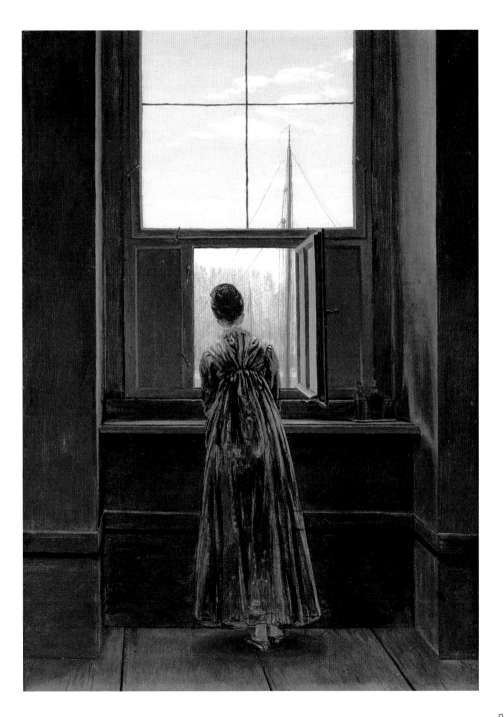

Village Landscape in Morning Light (The Lone Tree), 1822

Oil on canvas
55 × 71 cm
Alte Nationalgalerie, Staatliche Museen, Berlin

A companion piece to *Moonrise over the Sea* (pages 88/89), this painting poses
an alternative mode of human experience. The view is of a pastoral landscape with
the usual visual attributes, such as the shepherd in the foreground with his sheep,
a church spire in the distance and other references to human habitation such as
chimney smoke. It is evocative of a Claude painting and is in many ways similar to the
rural idylls of Friedrich's English Romantic contemporary John Constable (1776–1837).
Unusually for Friedrich, this painting allows viewers to navigate a safe passage into
the carefully mapped landscape, unencumbered by fog or mist. It lets them feel, like
the shepherd, at one with nature. The lush landscape is borrowed from an earlier
Friedrich painting, *Landscape with Rainbow* of 1809 (page 19), inspired by Goethe's
Shepherd's Lament, written in 1802. In this painting however, Friedrich has included
the Riesengebirge mountains in the background, perhaps suggesting that there is
something beyond what we can actually see.
Although Constable's landscape was unlike Friedrich's, they shared the same
aesthetic concerns, the search for a landscape that calmed the spirit, knowing that
nineteenth-century progress and culture were making this idyll harder to embrace.
As with so many of Friedrich's paintings, this one was almost certainly inspired by
Friedrich Schiller, who in his essay *On Naive and Sentimental Poetry* (1795) referred
to a landscape 'that had vanished from humanity', and suggested that poets (and
by extension artists) 'will either be nature or will look for lost nature'. Another
interpretation of the painting holds that the lone oak tree, the focal point of the
painting, dominates the landscape and outweighs the church spire to the right,
suggesting that nature is above any individual faith.

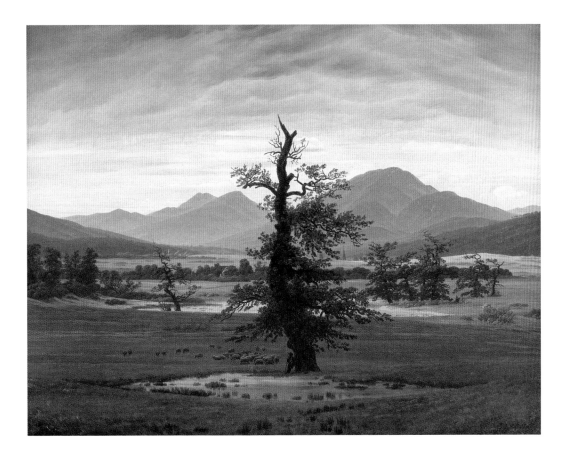

Hutten's Tomb, c. 1823/1824

Oil on canvas
94 × 73 cm
Klassik Stiftung, Weimar

Ulrich von Hutten (1488–1523) was a Teutonic knight, a follower of Martin Luther (1483–1546) and the Protestant Reformation. He took holy orders and became a monk before leaving to study theology at Greifswald University, becoming a scholar and a satirist of great wit, mainly against the Holy Roman Empire and the papacy. Disappointed at the speed of reform, he attempted to enforce Luther's doctrine by military means in what became known as the 'Knights Revolt'. His failure to prevail in the revolt led to his estrangement and poverty. He became a *Lehnsnehmer*, or vassal knight and sharply criticised the existing feudal system. Hutten's satirical critique of feudalism and commitment to Protestant reform made him a hero in Friedrich's eyes. Friedrich's view of Hutten's burial place is wholly imaginary. Wishing to pay homage to the man on the three hundredth anniversary of his death, he created the scene based on a sketch he had made during a visit to the ruined abbey at Oybin in 1810. The patriot's actual grave, on an island in Lake Zurich, is marked by a simple stone. Close inspection of the painting reveals the names of patriots from Friedrich's day, heroes in the recent Wars of Liberation. Like Hutten, these contemporary patriots had suffered persecution and neglect, this time under Prussian authoritarianism. One of those named, Joseph Görres (1776–1848), was still living at the time, and would spend his last years in exile in Strasbourg.
The inclusion in the painting of the soldier in *altdeutsche Tracht* (Old German attire) is a further patriotic touch.

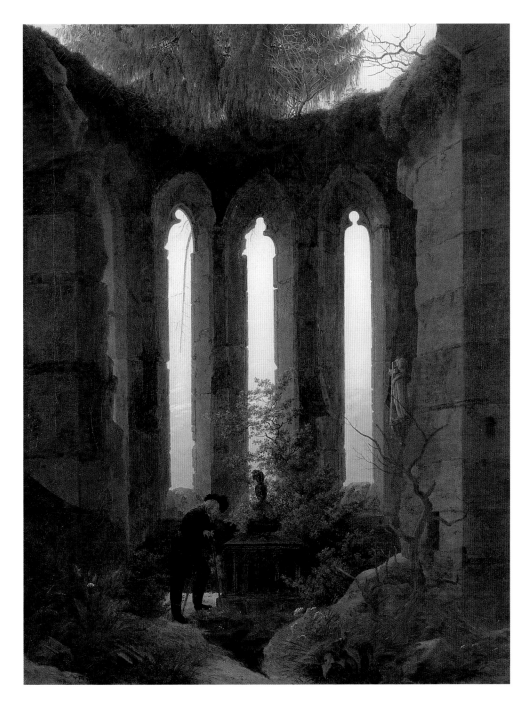

The Sea of Ice, c. 1823/1824

Oil on canvas
97 × 127 cm
Kunsthalle, Hamburg

Ship tragedies appear in a number of Romantic-era paintings as illustrations of the sublime power of nature, but they usually also contain a political message. In England, J. M. W. Turner's *The Slave Ship* of 1840 is one example, painted in the wake of the slave ship *Zong* massacre, in which the crew threw African slaves overboard to save drinking water. In France too, *The Raft of the Medusa* (1819) by Théodore Géricault (1791–1824) perfectly captures the aftermath of the sinking of the frigate *Medusé* in 1816. It is unclear what inspired Friedrich's painting *The Sea of Ice,* but it was very likely either the Arctic expedition of William Parry (1790–1855) in 1819 or the sinking of two British warships, HMS *Defence* and HMS *St George,* off the coast of Jutland in 1811. It is known that although Friedrich never visited the Arctic he made various sketches of ice floes on the river Elbe in winter. A more personal association may have been his having witnessed his brother's death after falling through the ice as a boy.

The stern of the ship is the only sign of a human presence, and attests to death, despair and tragedy. The scene of a ship crushed by the power of nature is a quintessential evocation of the sublime. Yet as in so many of Friedrich's melancholy paintings a bright blue sky holds the promise of salvation, here for the lost souls. The painting is a pathos-filled commentary on the fragility of human existence. It can also be seen as a metaphor for the oppressive crushing of liberal thought in Prussia at the time, so abhorred by Friedrich.

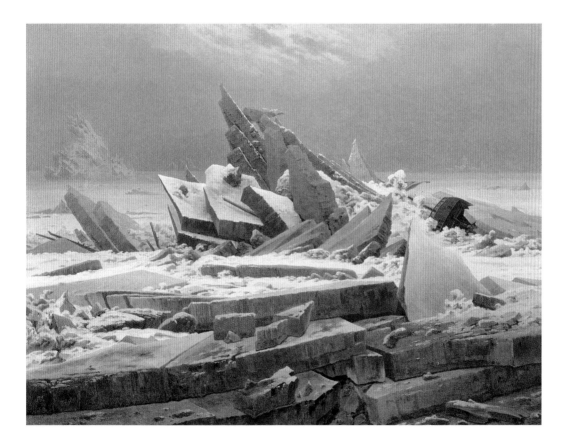

Hill and Ploughed Field, c. 1824

Oil on canvas
22 × 31 cm
Kunsthalle, Hamburg

The painting *Hill and Ploughed Field* was a work of immense spiritual importance
to the artist. It was set just outside Dresden in early autumn, as evidenced by the
sparse foliage on the trees. The arrival of a flock of scavenging crows signals that
the ploughing has just been completed. The ploughed field and the glow above the
skyline place the view in the evening. In the distance are prominent Dresden church
spires: on the left the Court Church, commissioned in 1738 by the Catholic Elector of
Saxony Frederick Augustus II (1696–1763), in the centre the unmistakable dome of the
Frauenkirche, a Lutheran church commissioned by the citizens of Dresden in 1726 and
completed in 1743. The two recall the religious divide in Dresden in the eighteenth
and early nineteenth centuries before Saxony was annexed by Prussia in 1815.
As in all of Friedrich's paintings there are symbolic and allegorical elements in the
picture. Ploughing is referred to several times in the Bible, most memorably by Jesus,
who said, 'No man putting his hand to the plough, but looking backward, is fit for the
kingdom of God'. It also appears as a metaphor for the receiving of truths, through
goodness, as 'harvest' is the reaping of those truths. Here there is a direct correlation
with the church, where truths are received. The flock of crows symbolises change or
transformation, so the viewer is being asked to reflect on earthly and sacred values.
Friedrich repeated this view in a later painting, *The Evening Star* (pages 36/37) of
1830–1835, where he included members of his family silhouetted against the sky.

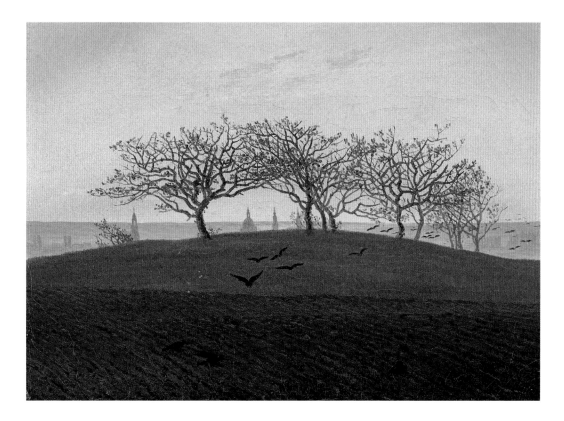

The Watzmann, 1824/1825

Oil on canvas
133 × 170 cm
Alte Nationalgalerie, Staatliche Museen, Berlin

One of Friedrich's most talented pupils was August Heinrich, who tragically died early, at only twenty eight. One of his most significant watercolour paintings, inherited by Friedrich, was his version of *The Watzmann*, from 1821. At two thousand seven hundred metres it is the highest mountain in the Alps wholly in German territory. At its peak is a large glacier. The painting is in all likelihood a metaphor for the 'journey of life', and particularly an homage to his young student.

Heinrich's small watercolour depicts only the mountain itself, without any foreground. A contemporary oil painting by Ludwig Richter (1803–1884) shows the Watzmann with a complex foreground that includes a waterfall, and it is probable that Friedrich saw that work when Richter submitted it to the Academy as part of his application for the post of professor of landscape painting – one that Friedrich also aspired to. Friedrich's portrayal of the foreground differs entirely and is a composite of other mountains and rock formations he had sketched in the Elbsandsteingebirge, on the border between Saxony and Bohemia, and in the Harz Mountains in Lower Saxony. A lone fir tree, symbol of Christ's eternal redemption of mankind, is strategically placed close to the centre of the composition.

The birch trees to the right of the rocks symbolise rebirth, or by extension, the Resurrection. One could conceivably scramble over the foreground rocks, but in the distance the landscape becomes more inaccessible. Most inaccessible of all, of course, is the glaciated peak of the Watzmann, nearly touching the top of the picture frame. Paintings of mountain peaks often carry the suggestion that they are where we are closest to God. This scene is accordingly a metaphor for the path of righteousness from earthly concerns to the hereafter.

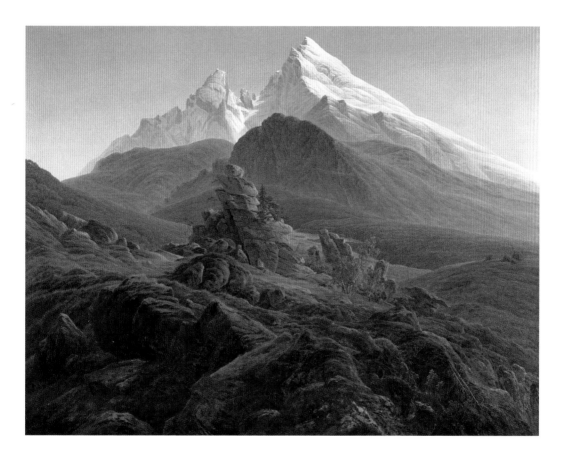

Trees and Bushes in the Snow, c. 1828

Oil on canvas
31 × 26 cm
Galerie Neue Meister, Staatliche Kunstsammlungen, Dresden

Friedrich has been referred to as the 'man of sorrows', a reference to the solitude he imbues on all represented things. His is a solipsistic gaze that was originally – and still is to a lesser extent – very difficult to understand. Many of his landscapes seem remote, untamed and inhospitable. *Trees and Bushes in the Snow* is one such painting that must have baffled its nineteenth-century viewers. Today one could almost classify it as an abstraction, but originally, like the late paintings of Turner, it was incomprehensible.

This very small painting pictures a thicket of bare alders, which in themselves have no symbolic meaning. Despite the work's diminutive size, there is something monumental about its motif. The picture space is almost completely filled with overlapping diagonals that block the view of anything beyond them but fog and dense cloud. There is nothing that provides the viewer a sense of scale. The viewer is not faced with a landscape, but only a landscape detail possibly overlooked in the past. Friedrich was asking the viewer to contemplate the thicket and provide it with his own solipsistic meaning.

The painting has an identically sized companion piece titled *Fir Trees in Snow* (page 35), another contemplative piece requiring the viewer's input. They were originally called *Dresden Heath I* and *Dresden Heath II* and were purchased as a pair by one of Friedrich's most ardent admirers and patrons, Georg A. Reimer.

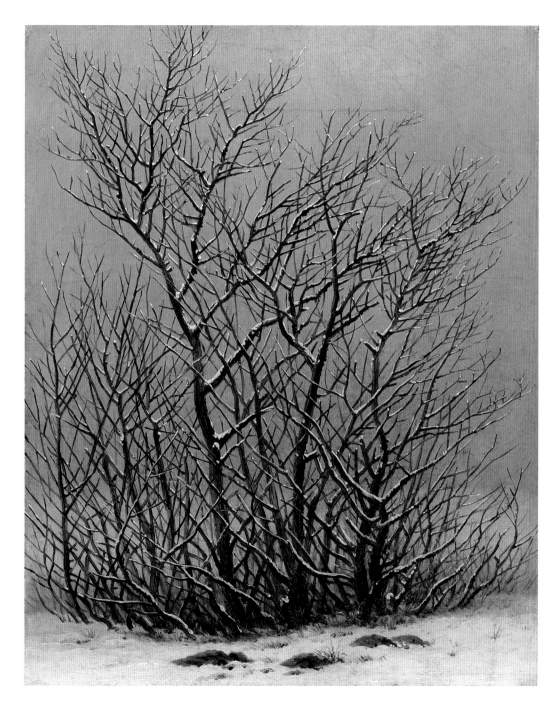

The Large Enclosure, c. 1832

Oil on canvas
74 × 103 cm
Galerie Neue Meister, Staatliche Kunstsammlungen, Dresden

The twentieth-century German philosopher Theodor W. Adorno (1903–1969)
described this work as the 'first modern painting'. Beyond a landscape's beauty or
sublimity, Adorno was more concerned with what he called its *Wahrheitsgehalt,* or
'truth'. Over a hundred years before, Friedrich was visited in his studio by the French
Neoclassical sculptor David d'Angers (1788–1856), who remarked that Friedrich
was introducing the 'tragedy of landscape', an evocation of man's existential
loneliness as he contemplates the inevitability of his death. For him, and later
Adorno, Friedrich's painting represented a distinct departure from the traditional
sentimental landscape painting of his precursors and the creation of one in which
the relationship between man and nature is spiritual. With its sonorous palette this
painting ranks as one of Friedrich's masterpieces and captures the very essence of
German Romanticism.

The Ostra-Gehege, or Large Enclosure, was a marshy tract surrounded on three
sides by a meander in the river Elbe. It was prone to flooding, creating small
streams that were partially navigable. In the painting *the only sign of a human
presence is the small sailboat in the middle distance. The flat foreground, with no
suggestion of an elevation just outside the picture, leaves the viewer with no place
to stand; he can only hover above the scene.* The vast space of the painting, with
no recognisable horizon, conveys a sense of infinity.

Before he painted this work possibly prompted by his own languishing reputation
and sales, Friedrich had written a series of aphorisms bemoaning the state of art in
Germany. He consoled himself by focusing even more intently on the river Elbe and
its surrounding landscape.

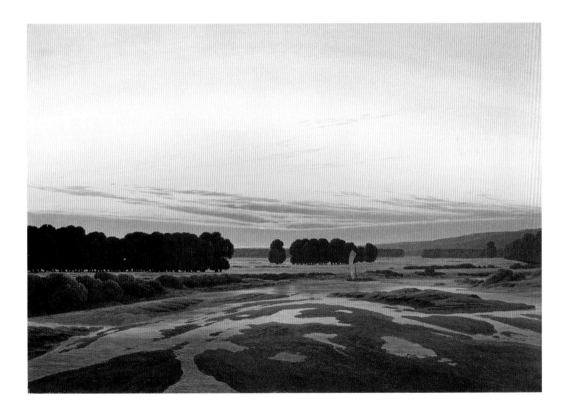

Graveyard in Moonlight, c. 1834

Brush, brown ink over pencil
14 × 19 cm
Département des Arts Graphiques, Musée du Louvre, Paris

Prior to his debilitating stroke in 1835, but already in poor health, Friedrich undertook a series of sepia paintings of graves and graveyards. As early as 1803 the artist had produced a similar drawing titled *My Grave*, early evidence of his lifelong obsession with death and his own mortality. Given the early tragedies in his life, it is unsurprising that he was aware of the fragility of life, of death as part of the human condition. It should be noted, however, that this particular painting was given to David d'Angers, so these images were not always self-referential. Given the presence of the open grave in the foreground, Friedrich may well have felt that the painting's viewer should also contemplate his own mortality.

Traditionally, owls are symbols of inner wisdom, but as nocturnal animals they can also symbolise sleep and death, as echoed in the full moon in the distance. The spade, apart from its literal use in digging the grave, may also refer to the Biblical story of Adam's having to dig the cursed ground to atone for his sin. If inverted, it resembles the grave markers seen in the background. A common feature of all Friedrich's funerary paintings is the use of a distinctive style of grave marker rather than a tombstone of his own time. A feature of Romanticism in England and Germany was the adoption of medieval motifs such as these, part of its revival of the Gothic style in architecture and the decorative arts. Medieval wooden grave markers were intended to be temporary, lasting for only a few years before being re-used for another interment. To Friedrich this may have suggested the transition from earthly life to heaven.

The Stages of Life, c. 1835

Oil on canvas
73 × 94 cm
Museum der bildenden Künste, Leipzig

Executed late in the artist's life, *The Stages of Life* is a summation of the many previous depictions of the human life cycle. The painting is an outpouring of his life and achievements, with the transiency of life symbolised by the arriving ships in the middle distance. The *Rückenfigur* on the left is probably Friedrich himself, recognisable from his long hair and *altdeutsche Tracht* (traditional German attire). He is walking towards his welcoming family aided by a stick, indicating his frailty in the autumn of his life.
The figure in the frock coat and top hat is most probably his nephew Johann Heinrich, who is beckoning his uncle forward. The trio in the centre of the composition are most probably Friedrich's children, his son Gustav Adolf, named after the king of Sweden and holding the Swedish flag, his daughter Agnes, who is trying to seize the pennant, and his oldest daughter Emma, who resembled her mother.
Allegorically, it appears that the tallest ship in the foreground has come to take Friedrich, while those in the distance will arrive much later to take the others on their final journeys. In a departure from Friedrich's normal practice of creating landscapes that are a combination of locations, this one is clearly identifiable as Utkiek near Greifswald, Friedrich's birthplace, at that time part of Swedish Pomerania.
The Swedish Romantic poet Per Daniel Amadeus Atterbom (1790–1855) said of Friedrich that he 'is a Pomeranian and considers himself half Swedish'.
It appears that the title of this work was applied retrospectively, long after Friedrich's death. The artist was not in the habit of allowing his titles to influence the viewer's contemplation of a work too greatly.

FURTHER READING

Amstutz, Nana, *Caspar David Friedrich – Nature and the Self*, New Haven 2020.

Börsch-Supan, Helmut, *Caspar David Friedrich*, Munich 2005.

Grave, Johannes, *Caspar David Friedrich*, Munich 2017.

Grummt, Christina, *Caspar David Friedrich: Werkverzeichnis der Zeichnungen*, Munich 2011.

Hofmann, Werner, *Caspar David Friedrich*, London 2001.

Koerner, Joseph Leo, *Caspar David Friedrich – On the Subject of Landscape*, London 2009.

Leighton, John, and Colin J. Bailey, *Caspar David Friedrich – Winter Landscape*, London 1990.

Rosenblum, Robert, et al., *The Romantic Vision of Caspar David Friedrich, Paintings and Drawings from the U.S.S.R.*, New York 1991.

Sala, Charles, *Caspar David Friedrich – The Spirit of Romantic Painting*, Paris 1994.

Vaughan, William et al., *Caspar David Friedrich – Romantic Painting in Dresden*, London 1972.

Wolf, Norbert, *Friedrich – The Painter of Stillness*, Cologne 2003.

PHOTO CREDITS